eat me

delicious, desirable, successful food packaging design

ben hargreaves

A RotoVision Book

Published and distributed by RotoVision SA
Route Suisse 9
CH-1295 Mies
Switzerland

RotoVision SA
Sales, Editorial & Production Office
Sheridan House
112/116A Western Road
Hove BN3 1DD
United Kingdom

phone +44 (0)1273 72 72 68
fax +44 (0)1273 72 72 69
email sales@rotovision.com
web www.rotovision.com

10 9 8 7 6 5 4 3 2 1

ISBN 2-88046-773-X

conceived and edited by Leonie Taylor
art directed by Luke Herriott + Violetta Boxill
designed by Violetta Boxill
@ Alexander Boxill
photography by Ivan Jones

Reprographics in Singapore by ProVision Pte. Ltd.
phone +65 6334 7720
fax +65 6334 7721

Printing and binding in China by Midas Printing Ltd.

eat me

delicious, desirable, successful food packaging design

ben hargreaves

RotoVision

contents

eat me (please!)

"Food packaging has always been divided into two parts in the US: name brands (boring, unimaginative, unchanging) and niche brands (innovative, conceptual, engaging). We prefer the latter, as do most designers. For design firms, niche brands are where the awards are, and name brands are where the profits are." Rick Braithwaite, president, Sandstrom Design, Portland, Oregon

Motivated by awards, or motivated by profits? If you're a designer, inevitably the answer is both. The gongs are great, but you've got to pay the bills. And the desire to produce something stunning, distinguished, that will last, is necessarily tempered by the commercial pressure to produce something that will sell to the largest possible audience in the greatest possible quantities—the best of all possible consumer worlds. Nowhere is this truer than in a fast-moving consumer goods sector such as food packaging: an area where it's perhaps harder than others to produce distinctive work, and commercial considerations are everything.

Domenic Lippa, a director at London design agency Lippa Pearce, likens working on food packaging to being at the coal face of design—by which he means there's just so much of it out there. Most of which isn't that good. It's a fact that the majority of the designers I interviewed for this book don't particularly rate food packaging design.

Ask Kit Hinrichs, say, head of graphics at Pentagram in San Francisco: his comments on the quality of the food and drink packaging designs for the products under which our supermarket and grocery store shelves are groaning is typical: "I'll be candid, there's a tremendous amount of mediocrity in the business. There are so many layers of people and marketing experts within the food companies concerned about market share and quarter percents of market share, and they don't want to try anything out of the ordinary. By the time the companies, researchers, and marketeers are through with a design, it looks like everyone else's. The deal stickers are on it, the product names are bigger, and the images have been retouched so much that they don't look real any more. It's just endemic—as if they're determined to kill whatever spirit was there."

Lippa has similarly strong views on the subject: "The products have to sell and things have really been dumbed down—there's more and more bad packaging design by bad packaging designers. It's hard to find good examples because there's so much dire stuff out there."

Oh dear. For a book purporting to be a showcase of the best in food packaging design, it looked like we might have fallen short of material.

Fortunately, there's great stuff out there, too. This book showcases some excellent design work in the field from across the world, from a broad range of agencies and designers. Some of the work featured is by people who specialize in food packaging: expert design by the foodie experts, such as Parker Williams' work for Sainsbury's Supermarkets in the UK. For others, food is a first foray, but one that proves that an outsider's perspective is no barrier to designing great food packaging—it may even be of benefit (see Smart Design USA's award-winning work for Oxo Grind It, page 148).

While they may have misgivings about its quality, none of the designers I spoke to doubted the importance of—to reemploy one of the section titles in this book—desirable packets. If packaging is the manifestation of the brand in the hand, then in our acutely brand-conscious times, it performs a critical function. In many cases, "It is the brand, or rather the embodiment and expression of the brand meaning," says Michael Coleman, vice president of Chicago's Source Design. Companies attempting to develop brands as well as mere products (and who isn't?) can ill afford, then, to ignore the packaging.

Indeed, the signs suggest that companies are paying more attention to this than ever before. Sandstrom Design's Rick Braithwaite makes the point that, "There is a growing desire by food companies to maximize the effectiveness of their packaging. This has resulted in an increasing willingness to change. Firms are looking to upgrade their look every two years, rather than every ten years, as in the past. They are no longer afraid that new packaging will confuse the consumer and disrupt their fragile

relationship with the brand. They have come to see packaging as an integral part of their marketing program, and are more willing to spend money to freshen it on a regular basis."

Food packaging can be seen as part of the larger branding project that companies of all kinds are keen to engage in. Selling product in itself is all well and good, but what these businesses really want to push at consumers is their brands. In food, a product as simple as a packet of crisps can—with the right packaging—become something essentially aspirational in character. Presented well enough, the wine you drink becomes as important as the trainers you wear and the car you drive. Companies are selling lifestyle, not peanuts.

There are, therefore, great opportunities out there for designers willing to bring their skills to the (dinner) table. The quality—in general—of food packaging is improving. As consumers' tastes in food and drink have become more sophisticated, so has their awareness of packaging design. Potential clients in the food and drink industry are on the lookout for new ideas. Ironically, the very factor that undermines the design values of food packaging—its ubiquity— also makes it an enormously exciting area to work in. It's nothing if not a democratic medium, after all: everybody has to eat. Kit Hinrichs adds: "I love the challenge of doing food packaging, because it reaches so many people. Even more, I love the challenge of doing something well that also becomes highly successful."

Perhaps you could make an analogy with another business dominated by dross: the music industry. The designer behind an outstanding food packaging design that also does tremendously well commercially must feel a bit like the musician behind a great album that unexpectedly goes multi-platinum.

Now feast your eyes…

Ben Hargreaves

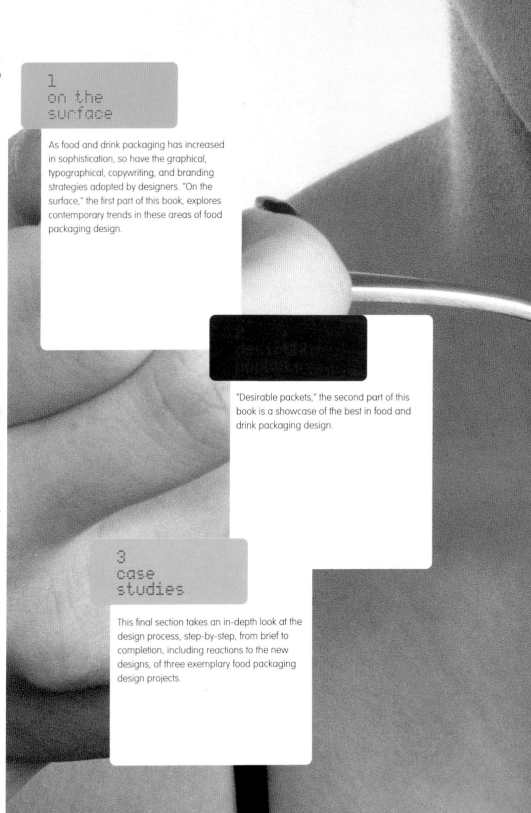

1
on the
surface

As food and drink packaging has increased in sophistication, so have the graphical, typographical, copywriting, and branding strategies adopted by designers. "On the surface," the first part of this book, explores contemporary trends in these areas of food packaging design.

2
desirable
packets

"Desirable packets," the second part of this book is a showcase of the best in food and drink packaging design.

3
case
studies

This final section takes an in-depth look at the design process, step-by-step, from brief to completion, including reactions to the new designs, of three exemplary food packaging design projects.

As food and drink packaging has increased in sophistication, so have the graphical, typographical, copywriting, and branding strategies adopted by designers. "On the surface" explores these areas of food packaging design.

11 on the surface

" I have what's called the 'billboard by the freeway' theory that I give to my clients. Whatever you do with your packaging—it has to be pretty, there's no doubt about that—it must also be absolutely clear: the customer going down the aisle in the grocery store is the same as the person driving down the freeway and passing a billboard. They're going to look at the billboard for maybe three seconds; if there's any confusion, any lack of clarity, they're gone. The key issue with food packaging is to communicate the value and benefit of the product instantaneously. The other big challenge is making it look fun, interesting, and giving it a sense of style. "

Mark Greene, Pecos Design, New York

graphics and typography

1: on the surface
look at me

13

Photography is obviously a key element in desirable packaging, but the style of photography for food and drink packaging has altered dramatically in recent years, becoming (somewhat paradoxically) both more and less honest. In the past, companies would go to great lengths to create a perfectly staged portrayal of a food product on the packaging. Modelmakers were drafted in to create immaculate facsimiles of food that bore little resemblance to the actual product (no surprise, then, that this approach didn't go down too well with consumers).

So, in a certain sense, photography has become more realistic. There is no longer any need, says Tamara Williams, creative director at Parker Williams, to "vacuum up all the crumbs" when shooting biscuits, and designers are happy to let the ice cream melt a bit while the photos are being taken. But that doesn't mean that the new photographic mode is any more honest than before—it's just got smarter as consumers have become more sophisticated.

Rather than manipulating the food (or models of the food), photography is now being used in a clever fashion to highlight the product's qualities and create the necessary foodie ambience. Williams suggests: "Photography is being used as illustration: we're seeing a lot of tricks and effects being employed to make the food look really special: there's an awful lot of atmosphere in food shots. It's not manipulating the food itself, it's changing the focus and the depth of field. You can put the foreground and background in soft and the mid-ground in focus—it really draws your eye to the part of the food you're meant to be

looking at. 'Texture' is the big word here: you really focus in on the product, whereas before you might have had a million things in the background. Photography has got cleverer."

Jacqui Sinnat, creative director at Butcher and Gunderson, describes this more recent approach as "editorial" in style: photography with a strong lifestyle element. "It's the kind of thing you'd find in a magazine—more relaxed than some of the traditional formalized, staged photographs."

Sinnat adds: "People are much more into a naturalized presentation of food, in a natural environment. As a style this has been around for five years and if you look at most modern food packaging it fits that description."

But designers need to be wary of thinking that a luscious, mouth-watering product shot is enough in itself. Michael Coleman, vice president, Source Design, Chicago, says: "There's a definite tendency to use visual trickery to attract attention, with all the gradations and vignettes you can pull off in Photoshop. It's fine if they are in service of an idea, but very often they are in exchange for, or in lieu of, an idea."

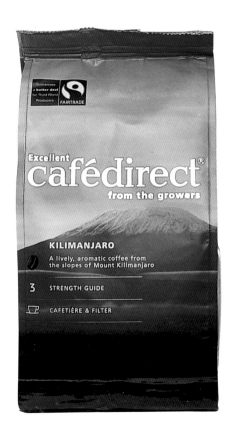

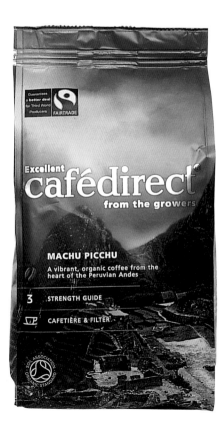

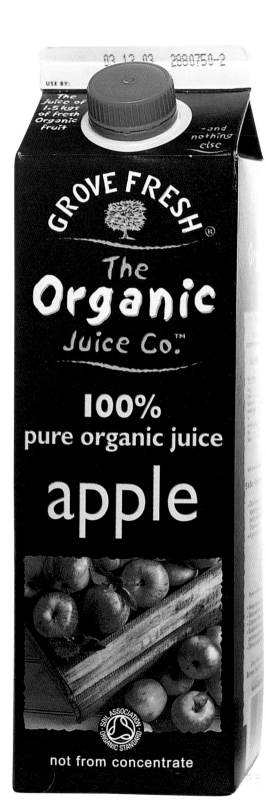

left to right

Café Direct
Beautiful, scenic shots of
the coffee's place of origin
clearly demarcate each
roast, while strengthening
the message that this
brand comes direct
from the growers,
supporting Fair Trade.
Designer unknown

Grove Fresh
Mouthwatering shots of the
organic fruit and vegetable
ingredients simply convey
the brand's emphasis on
100 percent organic juice.
Design by Campbell
Aylin Design

Clipper™
Stylish photography offers
a clear visual key to the
flavors of tea in the range.
Designer unknown

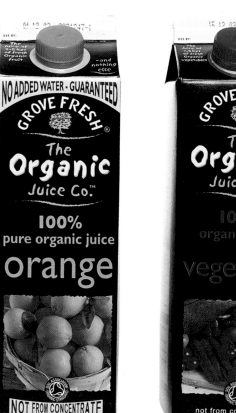

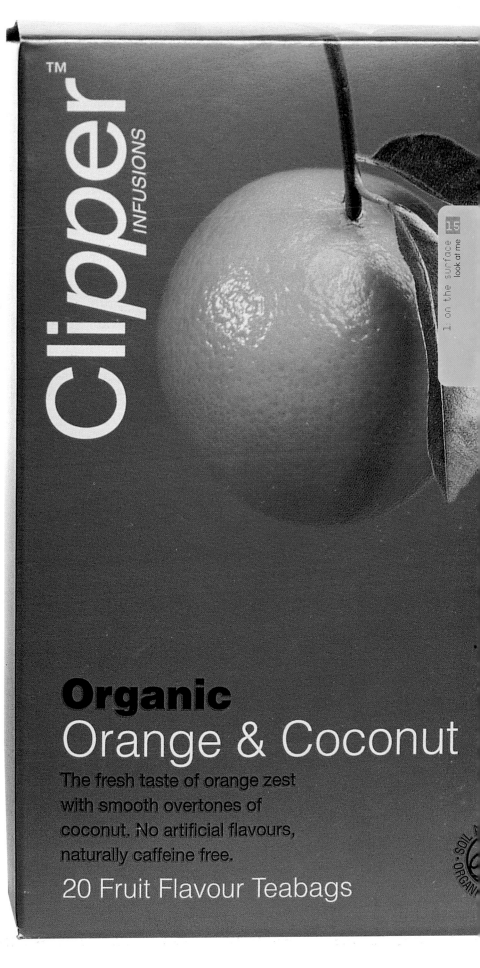

™

clipper
INFUSIONS

Organic
Orange & Coconut
The fresh taste of orange zest
with smooth overtones of
coconut. No artificial flavours,
naturally caffeine free.

20 Fruit Flavour Teabags

left to right

Imported Schnapps Shots
These Schnapps-filled chocolates playfully mimic drinks packaging with elements such as the cylindrical foil tin, and language such as "best served chilled."
Designer unknown

Nestlé Rowntree
Each sub-brand of Nestlé Rowntree employs a specially designed typeface which, combined with fun colors, creates strong, appealing, instantly recognizable identities that are rolled out over all product packaging and marketing. Designed by Nestlé Rowntree

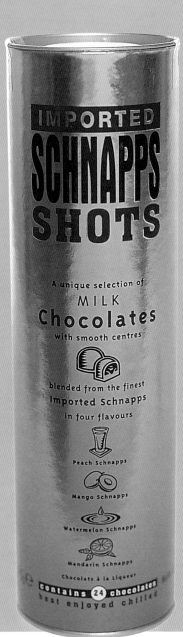

treating type

In the search for distinctiveness, brands often go down the route of creating their own logotypes and typefaces in the quest for ownability, even if the consumer doesn't notice the subtle changes that make a font a brand's own. For niche products, individualistic type treatments can also play an important part in creating distinctive packaging. Kit Hinrichs, of Pentagram in San Francisco, says: "There's more and more individual hand-lettered type, on smaller brands. It separates them from the slicker supermarket stuff and makes it a bit more personal."

There is also a trend toward more active type treatments, as Mark Greene of Pecos explains: "Type treatments are becoming more visually active; they're becoming skewed and distorted and there's an implied motion there. If you compare them with packaging from ten years ago, there's definitely a new vibrancy to the type treatments. Pick up any major product from a national brand and you're going to see evidence of this trend toward more active, playful type."

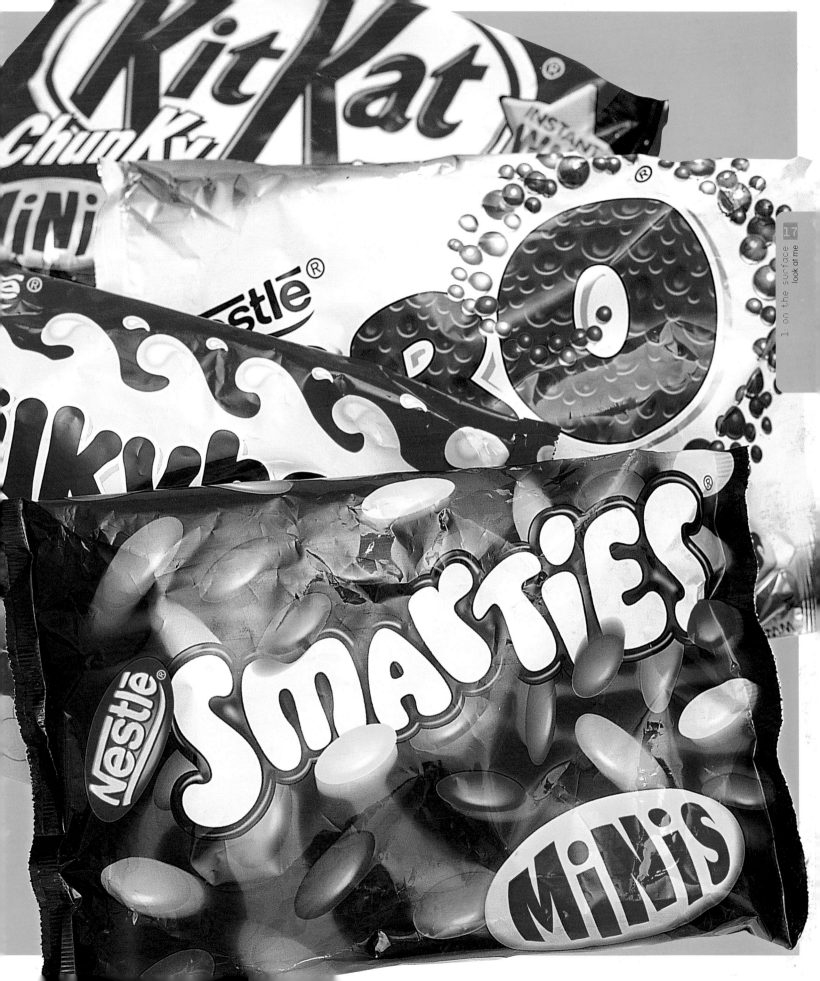

left to right

**The Really Interesting
Food Co.**

Green & Black's Organic

Shippam's Finest
Designers unknown

All these ranges use color
coding to represent different
flavors across their ranges.

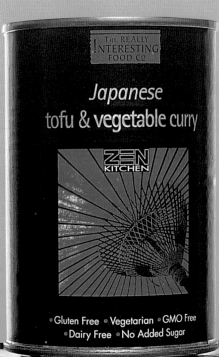

MILK

DARKER SHADE OF
MILK CHOCOLATE
100g e

GREEN & BLACK'S ORGANIC

DARK 70%

DARK CHOCOLATE WITH
70% COCOA SOLIDS
100g e

GREEN & BLACK'S ORGANIC

ALMOND

MILK CHOCOLATE WITH
WHOLE ALMONDS
100g e

GREEN & BLACK'S ORGANIC

CARAMEL

MILK CHOCOLATE WITH
A SOFT CARAMEL CENTRE
100g e

GREEN & BLACK'S ORGANIC

MAYA GOLD

DARK CHOCOLATE WITH
ORANGE AND SPICES
100g e

GREEN & BLACK'S ORGANIC

visual language and categories

In the supermarket where colors stand for market codes, it takes a brave brand to break from the norm, but if a certain type of product uses a certain color, there's a strong argument for using opposing colors to make a product leap out from the supermarket shelves. It's also important to achieve consistency in the use of color across a brand or retailer's ranges. "The color coding is vitally important, and retailers have some way to go," says Mary Lewis of Lewis Moberly. "There will be reasons why a retailer chooses a certain color that don't really relate to the way consumers see things. They need to put themselves in the shoes of the consumer. As a consultant for UK retailer Marks & Spencer, it's often my job to say: 'I don't understand this. Would your shoppers?'"

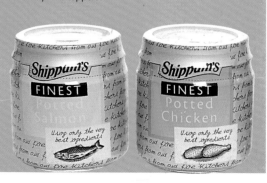

A positive trend—although it's by no means universal—is that marketers are beginning to recognize the value of clarity and simplicity of expression in food packaging graphics. Take breakfast cereals, for example, where historically there's always been a lot of visual disorder: some of the brands have responded by beginning to clarify and simplify their package presentation: basic ideas married to engaging graphics.

"You don't need five-color printing to achieve a great design: you can do really good things with two colors," says Domenic Lippa, co-founder of Lippa Pearce. But perhaps the motto here should be: keep it simple, but not stupid. Lippa adds: "The packaging for value ranges often treats the consumer like an idiot. It says: 'You can't afford anything better than this basic monochrome design that screams: "You are poor!"' To me, that's quite offensive."

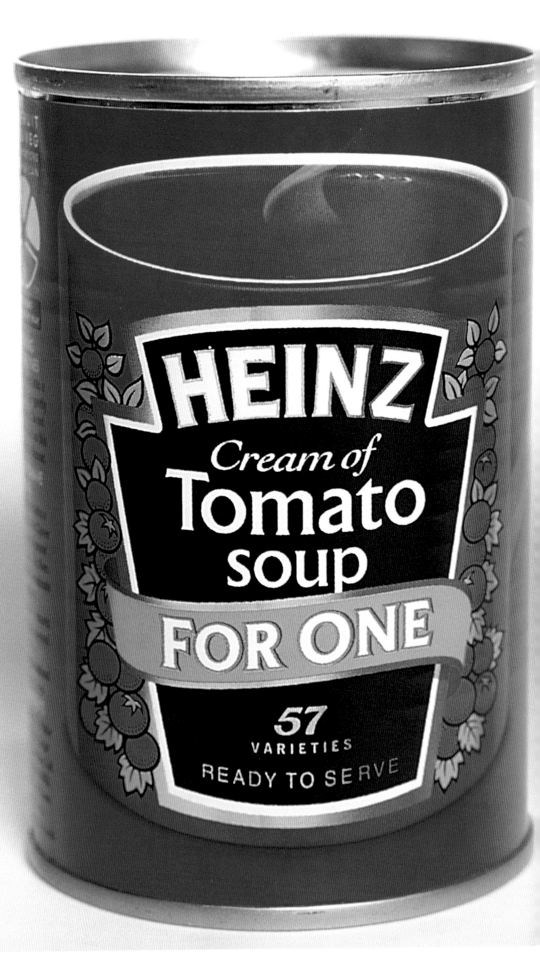

Heinz
Clear, simple branding, which has changed only incrementally over the years, makes this soup packaging highly memorable with a strong brand identity. Designer unknown

"Perhaps the most noticeable trend in packaging is the humanization of the product. Graphics, type, colors, and copy all are seeking to engage the consumer in dialog rather than acting as brand billboards. Simplicity and honesty are refreshing and effective. Cute and fancy will always work in niche markets like preserves and novelty soap, but timeline type and non-boastful copy has become the norm and is more effective. "

Rick Braithwaite, Sandstrom Design

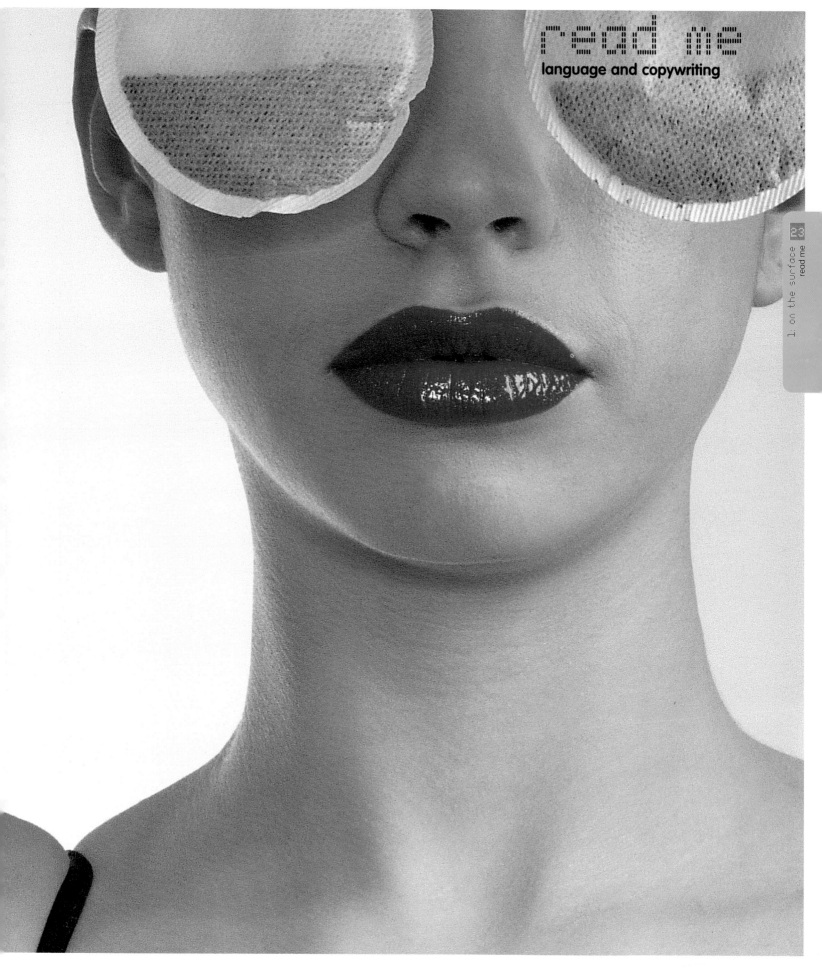

We named this flavour in 1987 for the legendary American guitarist Jerry Garcia after one of our fans sent us the idea on a postcard, and it's been one of our top hits ever since. We use only pure cream from lush farmlands to make the cherry flavoured ice cream smooth and sumptuous. Then we lace the ice cream with plump sweet cherries and dark chocolatey chunks. Enjoy!

Cherry Flavoured Ice Cream with Cherries & Dark Chocolatey Chunks

INGREDIENTS: CREAM 31.5%, SKIMMED MILK, WATER, CHERRY PREPARATION 11.5% (CHERRIES 88%, SUGAR), SUGAR, DARK CHOCOLATEY CHUNKS 5% (SUGAR, COCONUT OIL, COCOA 20.5%, MILKFAT, EMULSIFIER: SOYA LECITHIN, NATURAL FLAVOURS), EGG YOLKS, CHERRY SYRUP 1.5% (CHERRY JUICE 88.5%, SUGAR), STABILISERS: GUAR GUM AND CARRAGEENAN, NATURAL FLAVOURS.
Storage Instructions: Keep frozen below –18°C. For Best Before Date see bottom of container. Imported by Ben & Jerry's Homemade, Ltd., 10 Charter Place, High Street, Egham, Surrey TW20 9EA UK.
www.benjerry.co.uk
Cherry Garcia® is a registered trademark of the Estate of Jerry Garcia and is used under license.

Helado de cereza repleto de trozos de chocolate negro y cerezas

HELADO CREMA DE CEREZA CON CEREZAS
Y ESCAMAS CHOCOLATEADAS
INGREDIENTES: NATA 31,5%, LECHE DESNATADA, AZÚCAR, AGUA, CEREZAS 11% (CEREZAS 88%, AZÚCAR), ESCAMAS 5% (AZÚCAR, GRASA VEGETAL CACAO...
EMULGENTE...

Eiscreme mit
und k

ZUTATEN:
KIRSCHZUE
ZUCKER, KAKAOH
PFLANZENFETT, I
LECITHINE (SOJA
STABILISATOREN GU.
Bei –18°C mindeste
Import: Ben & Jerry's
www.ben-and-jerrys.d

Crème Glacée avec d

INGREDIENTS: CRE
A BASE DE CERIS.
PEPITES DE CHOCOLAT
CACAO 20,5%, MATIERE GRA
DE SOJA, AROMES NATURELS
(JUS DE CERISE 88,5%, SUCRE
CARRAGHENANES, AROMES
Conservation: Conserver à
préférence avant la date ind
Consommateur Ben & Jerry's
92 842 Rueil-Malmaison Ceda

Körsbärsglass och bitar me

INGREDIENSER: GRADDE
KÖRSBÄRSBEREDNING
SOCKER), SOCKER, BITAR M

Although obviously integral to advertising and other media, copywriting is something that has been broadly overlooked in packaging design—until relatively recently. Designers are cottoning on to the fact that language, when used in an innovative way, can add genuine value and depth to a brand.

Brands like Ben & Jerry's ice cream are notable for employing a distinctive tone of voice on their packaging. The whimsical babyboomer patter of Ben & Jerry's language—e.g.: "Just us two stoned hippies against the big bad world of business, lackadaisically slinging handfuls of pecan nuts into the tub"—is, perhaps, a little hackneyed, but there are some great examples of this device being used.

The packaging for Innocent fruit smoothies, for example, is witty and personalized, with copy designed to charm the consumer, presenting the brand not as the work of another anonymous corporation, but as something with real people behind it. Puns (TM on an Innocent bottle might also stand for "tasty mixtures"), references to popular culture ("Christina Aguilera rocked our world"), humorous additions to ingredients lists ("a few small pebbles," "1 small church"), and invitations

Ben & Jerry's
This convivial company uses familiar, whimsical language on its packaging to create a distinctive tone for the brand that communicates on a personal level with the consumer.
Designer unknown

>>>>>>

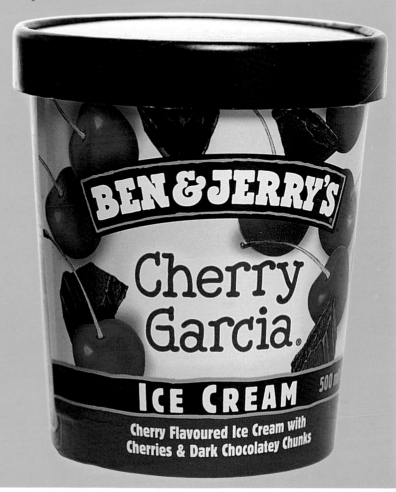

Innocent
Honesty and humor are
employed as linguistic
tools on this packaging to
engage the consumer and
build trust in the integrity
of the brand.
Designed by Innocent's
in-house design team

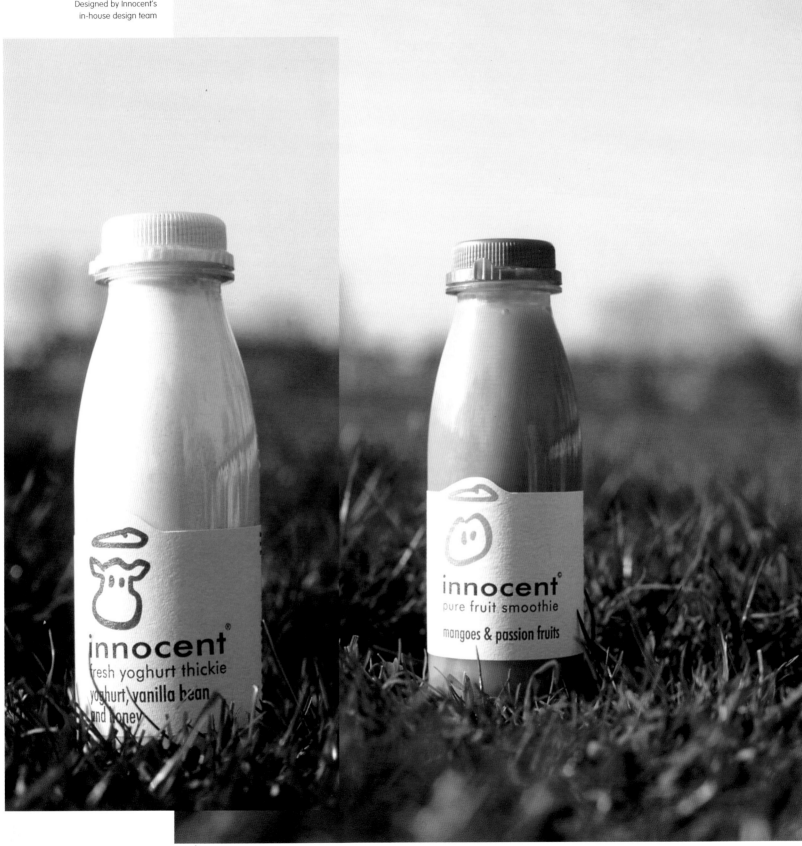

Ingredients (minimum contents)
2½ pressed apples,
6 crushed strawberries,
½ mashed banana,
a dash of freshly squeezed orange juice
and a few small pebbles*.

Nutritional information (per 100ml)
Energy 196Kj (47 Kcal)
Protein 0.4 g
Carbohydrates 10.7 g
 of which sugars 10.3 g
Fat 0.2 g
Fibre 0.6 g
Sodium 7 mg
Vitamin C 38 mg
Innocent 100 %

This bottle provides
150% RDA of natural Vitamin C

*we lied about the pebbles

5 038862 320108

We usually write funny things on this bit of the label, but it's 2000. Our New Year's resolution is to give you, the consumer, straight information. No gags, no jokes, no clever word-play. Just some writing on the side of a bottle.

Call us boring, but we'd like the contents to speak for themselves. ¼lb of pure fruit, which translates as your daily fruit intake, giving you 1½ days' worth of vitamin C, with no concentrates or additives of any kind. We'd like to apologise for any jokes you may find elsewhere on our labels - we are working on this problem.

Why not say hello?
Drop a line or pop around to Fruit Towers, 6 The Buspace, Conlan Street, London W10 5AP

Call the banana phone on 020 8969 7080 or visit our online gym at www.beinnocent.co.uk

TM = Throat Massage

We want you. No, honestly, we really do. Things are going better than we ever could have hoped for with innocent smoothies so we need some nice people to come and help us up at Fruit Towers.

If you're reading this then you've passed the first test as we want people who love fruit. We also need people to be able to help with either the selling or the marketing. What do you think? If it sounds like your cup of tea then email us at itsoundslikemycupoftea@freshtrading.co.uk.

Why not say hello?
Drop a line or pop around to Fruit Towers, 6 The Buspace, Conlan Street, London W10 5AP

Call the banana phone on **020 8969 7080** or visit our online gym at **www.beinnocent.co.uk**

© = Career-opportuntiy

to consumers to "pop round and say hello," or call the "banana phone," are all heady parts of a linguistic brew that is succeeding in its mission to engage the consumer with the brand. Thankfully, Innocent has recognized that the copy is unlikely to have the same impact the second or third time around—therefore it changes constantly.

Dan Germain, Innocent's brand guardian (a job title that is surely also a sign of the company's fresh approach), says: "With our packaging, the whole name suggests purity anyway, and a bit of honesty about our product. We're not trying to slip any nasty ingredients in there, just what it says on the panel: fruit, fruit, and more fruit. When you talk to people about packaging they all say, 'You've got to have something that stands out on the shelves.' A lot of the packaging out there is just bright, garish stuff. We felt the way to stand out was to do something simple and uncluttered."

Innocent's innovative use of language extends to the creation of a small book on healthy eating and smoothie recipes, although Germain is aware that the copy is by no means the most important factor. "We haven't written a book on Innocent's philosophy or history as such, although publishers have approached us. We give plenty of good advice on the bottles and in the books, but we don't want to seem as if we're showing off or being arrogant. The important thing is really that we carry on making great drinks: the funny labels and books—that's fine, but we don't want it to take over."

>>>>>>

Thou shalt not commit adultery. You said it big guy. That's one guideline we follow religiously; our smoothies are 100% pure fruit. We call them innocent because we refuse to adulterate them in anyway.

Wherever you see the dude ☺ you have got our cross-your-heart-hope-to-die promise that the drink will be completely pure, natural and delicious. If it isn't, you can ring us on the banana phone and make us beg for forgiveness.

Amen.

Why not say hello?
Drop a line or pop around to Fruit Towers, 6 The Buspace, Conlan Street, London W10 5AP

Call the banana phone on 020 8969 7080 or visit our online gym at www.beinnocent.co.uk

® = Religious-experience

Taylor's of Harrogate
Coffee flavors across the range have quirky names such as "Hot Lava Java," "Lazy Sunday," and "Feel Good," playfully categorizing the roast of the beans or the "mood" of the coffee.
Designer unknown

Brianna's Home Style
Simple, friendly language is used to convey the taste of the products and their ingredients. The Poppy Seed Dressing, for example, is illustrated by a peach, with the label "Delicious On Fresh Peaches. Does Not Contain Peaches."
Designer unknown

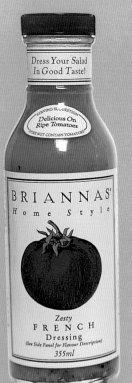

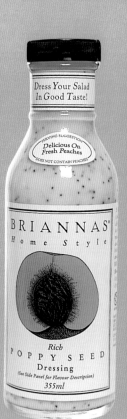

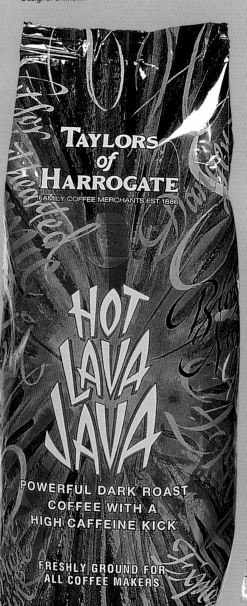

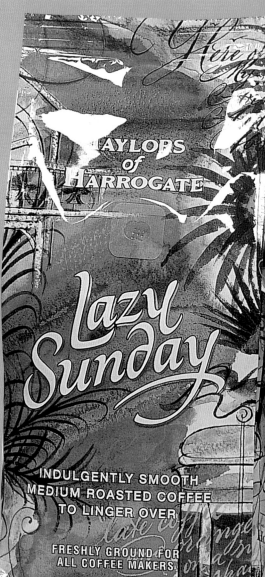

Theresa Whitehill, founder of San Francisco agency Colored Horse, says that her writing skills are an invaluable part of the package she offers clients. "I'm also a poet—having skills in writing really comes in handy for the business. A lot of graphic designers don't really have composition skills, and when people find out I can write copy too, they get really excited. Coming up with a compelling, catchy tagline for a company helps so much in positioning it. Along with my design work, I often play with different copylines for different packaging: I find it's like giving clients their mission statement—or vision statement."

Whitehill sees the use of copy as part of a trend toward greater humanization of the packaging for food and drink products, a point on which Rick Braithwaite of Sandstrom Design concurs: "Perhaps the most noticeable trend in packaging is the humanization of the product. Graphics, type, colors, and copy all are seeking to engage the consumer in dialog rather than acting as brand billboards. Simplicity and honesty are refreshing and effective. Cute and fancy will always work in niche markets like preserves and novelty soap, but timeline type and non-boastful copy has become the norm and is more effective. We've always tried to use copy to engage consumers in the purchase decision [see Sandstrom's work on Miller Lite, page 148, and Hollywood Video, page 39], and think it will continue to be a powerful marketing tool."

Copy can also be used to give products that all-important sense of provenance (a key recent trend in food packaging, see page 41), or an idea of the food or drink in question's origin. Tamara Williams, creative director at Parker Williams, suggests: "I'm obsessive about the words on packs: the trend in

>>>>>>

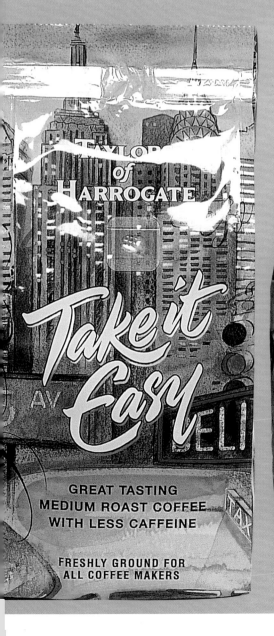

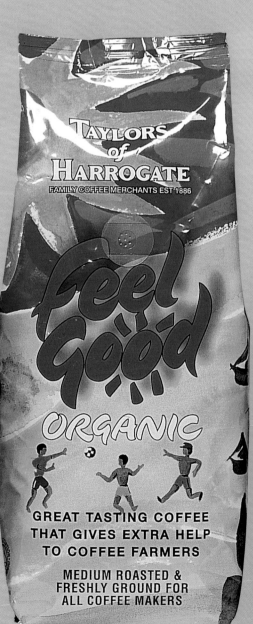

AN AUTHENTIC JAMAICAN BLEND OF HERBS AND SPICES TO CREATE A 'HOT' MARINADE. THE TRADITION OF 'JERKING' MEAT IS UNIQUE TO JAMAICA. ORIGINALLY APPLIED TO WILD BOAR IN THE 17TH CENTURY, IT IS NOW AN INTEGRAL PART OF JAMAICAN LIFE. STREETSIDE VENDORS COOK JERKED PORK AND CHICKEN OVER HOT CHARCOAL AND BRANCHES OF PIMENTO. THE AROMA IS IRRESISTIBLE AND THE TASTE DELICIOUS.

TO JERK MEAT, CHICKEN OR FISH: USE 1 TO 2 TEA-SPOONS OF JERK SEASONING PER 1LB OF MEAT OR FISH. RUB THE SEASONING WELL IN WITH OIL AND ALLOW TO STAND AND MARINADE FOR AT LEAST ONE HOUR. GRILL OR BARBECUE UNTIL GOLDEN BROWN.

JERK PORK IS UNIQUE TO JAMAICA. IN THE SEVENTEENTH CENTURY FUGITIVE 'MAROONS' DEPENDED ON THIS ORIGINAL PRACTICE OF COOKING.

TRADITIONALLY, JERKED MEAT IS COATED WITH SEASONINGS AND COOKED ON A LATTICE OF SMOKING PIMENTO BRANCHES OVER HOT CHARCOAL. THE MOUTH-WATERING AROMA FROM STREETSIDE BARBECUES ENTICES MANY A HUNGRY TRAVELLER.

BEST BEFORE
SEE BASE

Busha Browne's
The copy on the packaging for these Jamaican condiments for Jerk dishes summarizes the history of the dishes, building a "brand story" that strengthens the consumer's perception of its authenticity.
Designer unknown

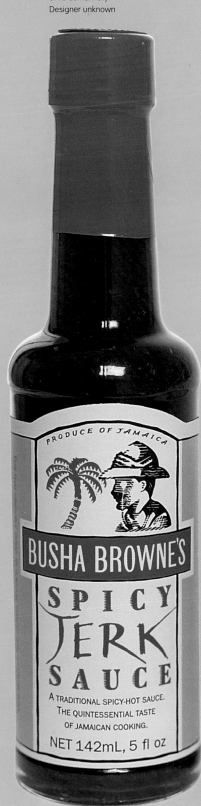

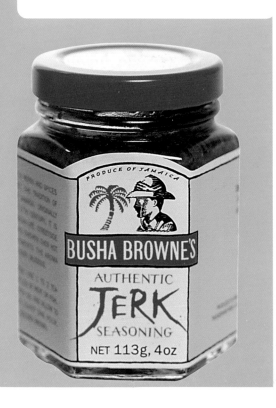

packaging language is now really to explain the taste of things: where the tomatoes were grown, for example. Things are being broken down to a much more conversational level now, and that's because consumers are wiser about these things. They can't be conned anymore."

But whether smart, sassy, warm, or provocative, copy also has a very important functional role to play in relaying information to the consumer. In our health-conscious times, consumers need to be able to weigh up the nutritional information of packaging quickly, and that information needs to be presented concisely and clearly.

Williams adds: "Communication is so important. The labeling on products is a lot cleaner and clearer than it used to be, and that's entirely necessary. There's a demand from consumers to have that information on the front of the pack to enable them to make decisions quicker."

Martin Grimer, at Coley Porter Bell, adds: "We now prefer to look on packaging as another form of media: you read it. That's why the way language is employed on packaging is becoming so important."

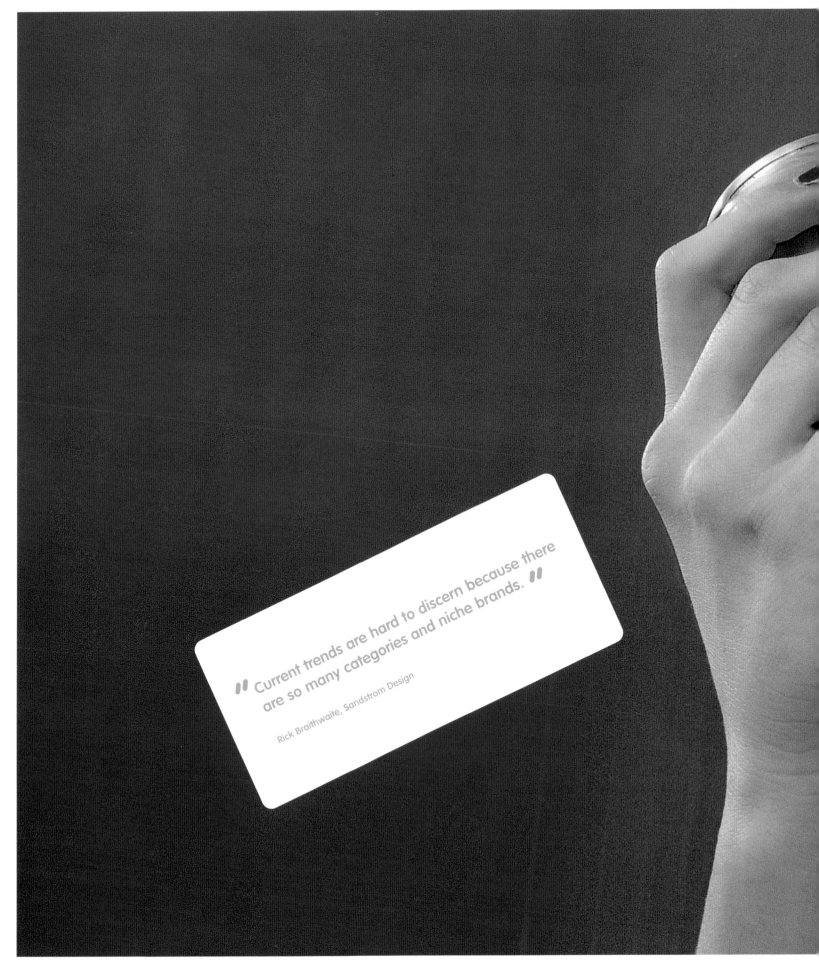

" Current trends are hard to discern because there are so many categories and niche brands. "

Rick Braithwaite, Sandstrom Design

follow me

International trends in food packaging design

It is not always easy to go trend-spotting—particularly in the area of packaging design, as it encompasses so much variety and contains such a broad range of product.

On both sides of the Atlantic, however, food packaging designers have seen their craft develop and mutate in response to commercial changes. As consumers have become more sophisticated, so have the designs adorning the packaging of the giant brands, premium lines, and own-label products. Even if commercial considerations reign supreme at the "coal face" of food packaging design (making innovation scarce, and good design rarer still), achieving that all-important shelf standout has seen the more progressive brands and retailers—and the designers they rely on—adopt some common strategies for advancement. Here are six of the most visible trends in international food and drink packaging:

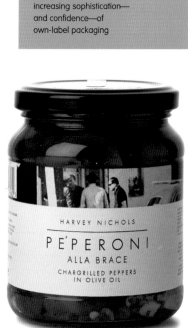
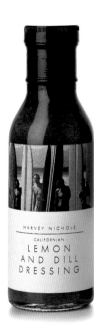

left to right

Harvey Nichols
Designed by Michael Nash

Selfridges
Designed by R Design

These designs embody the increasing sophistication—and confidence—of own-label packaging

HARVEY NICHOLS
OLIVE OIL
750ml e 25.3floz

HARVEY NICHOLS
EXTRA VIRGIN
OLIVE OIL
0.5lt e 16.9floz

HARVEY NICHOLS
PROVENCE
HERB
VINEGAR
6°
net 8½floz 25cl

HARVEY NICHOLS
PE'PERONI
ALLA BRACE
CHARGRILLED PEPPERS
IN OLIVE OIL

HARVEY NICHOLS
CALIFORNIAN
LEMON
AND DILL
DRESSING

1
the irresistible rise of own-label packaging

A decade ago, own-label packaging was inestimably poorer in quality than its contemporary counterpart. Often involving little more than a "me too" rip-off of more established products, it lacked confidence, class, and credibility. Retailers were content to produce copycat versions of the big brands' designs—until the legal challenge of the brands under threat curtailed this practice.

Things have changed to such an extent that it's hard nowadays to say whether it's the big brands or the retailers that lead the way in packaging design. Facing up to some serious competition from own-label ranges, the brands in turn have had to innovate to make an impact.

"In the US, private-label packaging used to be just throwaway; the retailers would just get some kind of half-assed design template and bang out product labels," says Mark Greene, founder of New York's Pecos Design. "In the past ten years, private-label has come to directly challenge national brands in terms of the sophistication of the packaging design and the degree of quality of the products."

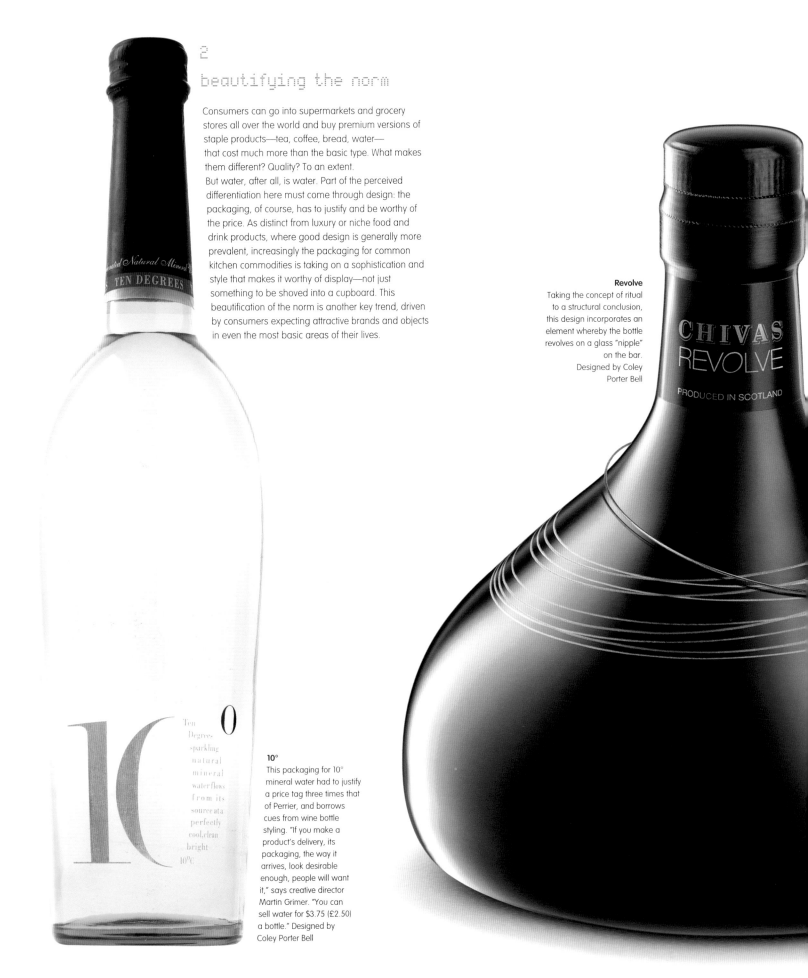

beautifying the norm

Consumers can go into supermarkets and grocery stores all over the world and buy premium versions of staple products—tea, coffee, bread, water— that cost much more than the basic type. What makes them different? Quality? To an extent. But water, after all, is water. Part of the perceived differentiation here must come through design: the packaging, of course, has to justify and be worthy of the price. As distinct from luxury or niche food and drink products, where good design is generally more prevalent, increasingly the packaging for common kitchen commodities is taking on a sophistication and style that makes it worthy of display—not just something to be shoved into a cupboard. This beautification of the norm is another key trend, driven by consumers expecting attractive brands and objects in even the most basic areas of their lives.

Revolve
Taking the concept of ritual to a structural conclusion, this design incorporates an element whereby the bottle revolves on a glass "nipple" on the bar.
Designed by Coley Porter Bell

10°
This packaging for 10° mineral water had to justify a price tag three times that of Perrier, and borrows cues from wine bottle styling. "If you make a product's delivery, its packaging, the way it arrives, look desirable enough, people will want it," says creative director Martin Grimer. "You can sell water for $3.75 (£2.50) a bottle." Designed by Coley Porter Bell

Guinness
Guinness distinguishes itself as the perfect drink worth
waiting for. Designer unknown (The Guinness word and Harp
device are trademarks of Guinness & Co.)

3

all the world is staged

Theater and ritual have become increasingly important for food and drinks brands attempting to distinguish themselves in a crowded marketplace. For global beer brand Guinness, the concept of "waiting for the perfect pint" has become as intrinsic to the meaning of the product as the qualities of the drink itself. It has become a brand with an ingenious— and, in today's high-speed, fast-food, on-the-move world, pleasingly contrary—selling point: the ritual of waiting. Fundamentally unnecessary, this element of theater in the way the drink is presented sets Guinness apart from other beverages. Many food and drinks companies are now exploring the potential of using such devices and rituals to add personality and distinction to their products. The experiential side of a product's delivery can be used to good effect to strengthen a brand with consumers, introducing an element of interactivity that reaches beyond cash transaction followed by consumption.

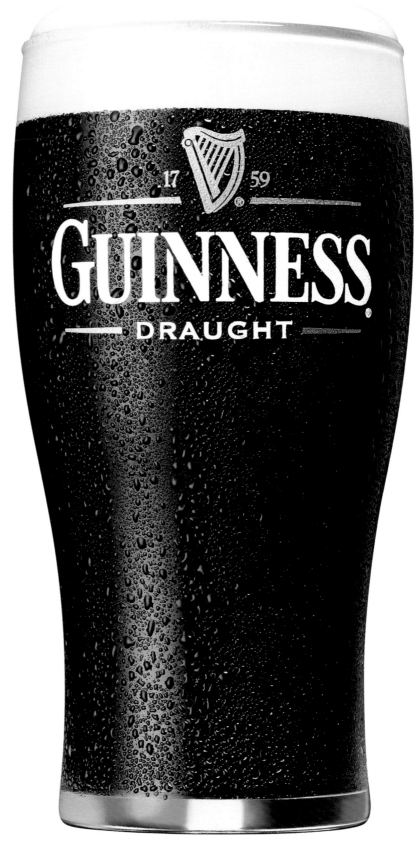

1: on the surface
follow me

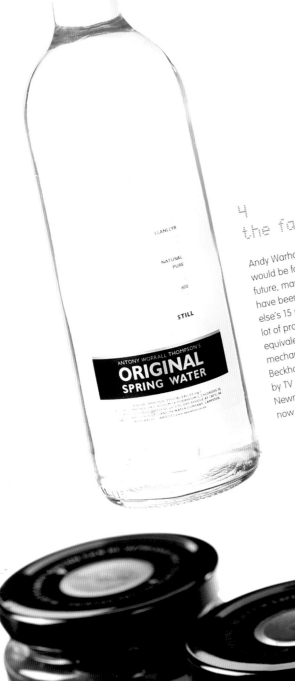

ORIGINAL
SPRING WATER

4
the fame game

Andy Warhol commented that in the future everybody would be famous for 15 minutes. Actually, in the future, marketers have realized—and consumers have been persuaded—that buying into someone else's 15 minutes is the perfect strategy for shifting a lot of product. Consequently we have the foodie equivalent of the gargantuan sports marketing mechanism that is Tiger Woods and Nike, or David Beckham and Adidas: the line of products endorsed by TV celebrity chefs and actors (such as Paul Newman). Similarly, many prestigious restaurants now market their own lines of products for the home.

Antony Worrall Thompson's
A range of items bearing the image of the celebrity chef imbues the product with kudos.
Designed by Lemon

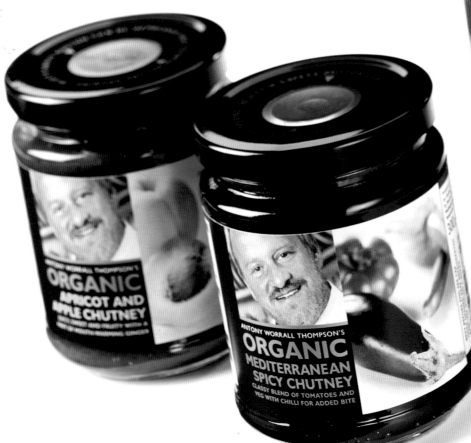

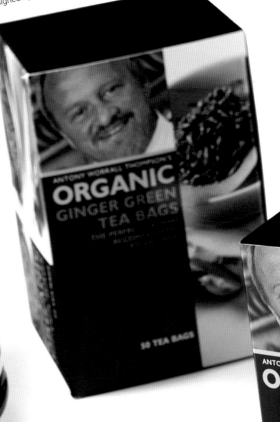

5
playful pillage

In this trend, brands—in food and drink particularly—
cheerfully borrow from other types of product or
experience, appropriating structures, graphics, and
linguistic devices from different areas. For example:
US video rental chain Hollywood Video wanted to
create a line of private-label snack items to be sold in
its 2,000 stores. With the archetypal film industry
association already in its name, Hollywood Video
wanted to reinforce its close connection to the movie
business. Designers at Sandstrom in Portland,
Oregon, recommended adopting movie poster-like
graphics and product names closely aligned with
well-known movies.

The result? Hollywood Video's Bucket and the
Butter popcorn packaging includes the slogan "All the
movie fun without the sticky floors." A full line of nut
products was also developed for the client as part of
its snacks range. Each product features a poster-style
graphic that is similar to a well-known movie, and
includes "reviews" from experts. "You may not be
able to handle the truth. But you're going to love
these mixed nuts... Mixed Nut Review."

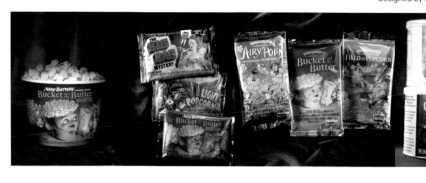

1: on the surface
follow me

**Cadbury's
Miniature Heroes**
This design features
a structural
element from the
cinema—a popcorn
bucket-style container.
Designed by Coley
Porter Bell

Cobra

The icons that appear on the Cobra bottles tell the story of the beer's heritage and brand story:

The elephant icon represents "youth acquiring enlightenment from seniority". The elephants also symbolize the two different bottle sizes—330ml and 660ml—in which Cobra is available.

The icon of the snake charmer portrays the "magic" behind Cobra.

The scales, initially, were weighed against Cobra. The beer was exported from India to the UK in the middle of a recession, in a market that was dominated by long-established brands.

The "B" on the building stands for Bangalore, the city in which Cobra was first brewed. However, it also stands for the (rather less exotic) location of Bedford in the UK, where the brand is now produced.
Designer unknown

6
provenance = premium

People nowadays are interested in where their food comes from. This is partly due to the impact of serious food scares such as the BSE crisis and outbreaks of hoof and mouth disease in British livestock herds. It's also a trend driven by the greater levels of international travel that modern consumers engage in, and their growing first-hand knowledge of other cultures and cuisines.

If justifying a premium, it's particularly crucial to give buyers some sense of a product's origin and authenticity. It's not just knowing the name of the farm where those free-range eggs come from, for instance—more knowing the name of the farmer, the kind of boots he wears, and the name of the individual chicken that laid them. "Provenance is especially critical on premium lines—you've got to have a good reason to buy," says Tamara Williams, creative director at Parker Williams, London.

A sense of origin can obviously be achieved through copywriting, but pictures, as they say, speak a thousand words. Cobra Beer, an Indian brand of premium lager that has reached an international audience (the beer is now exported to over 30 countries around the world), demonstrates the power of provenance in the most recent design of its packaging. Intended to communicate the brand's "style and quality" as well as its Indian heritage, the story of Cobra's development is told through a series of six icons embossed in relief on the bottle. "The product integrates its story visually, directly into packaging," explains Cobra chief executive Karan Bilimoria. "Having always offered consumers a genuine difference in taste and quality, the brand now bears an exclusive look."

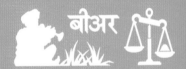
बीअर

Wild Sensation Salsas
These Australian-born premium-brand salsas employ simple, unadorned jars with tag labels to convey homemade feeling.
Designer unknown

" Packaging is the manifestation of the brand in the hand. **"**

Martin Grimer, Coley Porter Bell, London

own me

packaging as an extension of the brand

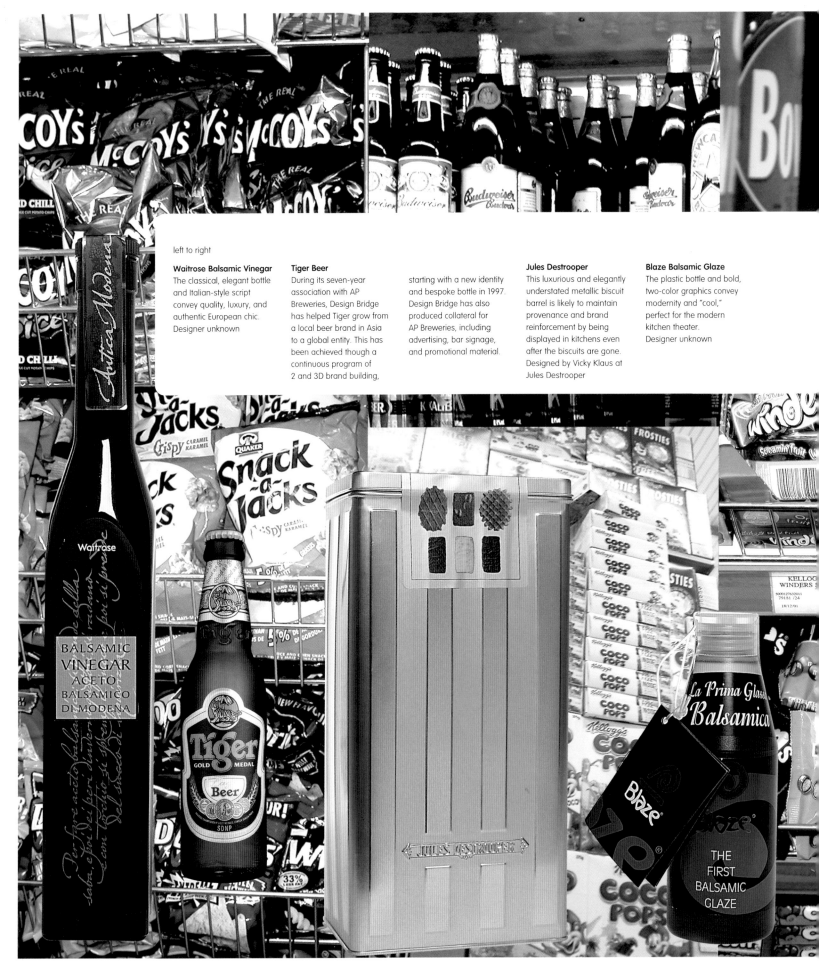

left to right

Waitrose Balsamic Vinegar
The classical, elegant bottle and Italian-style script convey quality, luxury, and authentic European chic.
Designer unknown

Tiger Beer
During its seven-year association with AP Breweries, Design Bridge has helped Tiger grow from a local beer brand in Asia to a global entity. This has been achieved though a continuous program of 2 and 3D brand building, starting with a new identity and bespoke bottle in 1997. Design Bridge has also produced collateral for AP Breweries, including advertising, bar signage, and promotional material.

Jules Destrooper
This luxurious and elegantly understated metallic biscuit barrel is likely to maintain provenance and brand reinforcement by being displayed in kitchens even after the biscuits are gone.
Designed by Vicky Klaus at Jules Destrooper

Blaze Balsamic Glaze
The plastic bottle and bold, two-color graphics convey modernity and "cool," perfect for the modern kitchen theater.
Designer unknown

Packaging is a unique form of media. It is something that consumers carry around with them, study intently, bring into their homes, and store on a regular basis. It is still there long after the TV channel has been changed or the radio station switched. Packaging is where the consumer finally comes into tangible contact with a food and drink brand, and the relationship between a product's brand values and the packaging is thus of tremendous importance. For some products—and particularly for products from smaller companies with smaller marketing budgets—the package can be the advertisement, the marketing campaign, and the packaging rolled into one. For larger brands, the packaging supports media and promotional campaigns in a crucial way.

"Packaging is one of the only forms of branding that interacts directly with the consumer in their home," says Ambur Rector, a designer at FutureBrand in New York. "Ideal packaging appeals not only to vision but to all of the senses. A well-designed package appeals to touch— through convenience and ergonomics—promises and delivers good taste and aroma, and often has a sound attached to it that indicates quality or freshness, such as the pop a Snapple cap makes when you first twist it off. Package quality is often seen as a sign of product quality and can go a long way to enhancing the image of a brand. Successful brands can often find themselves in the home for years, and sometimes generations. This can create significant relationships with the consumer who, in turn, will continue to exhibit strong brand loyalty."

" Packaging is people's perception of the brand; it's that core. It is your single most expensive form of advertising; and if you're a small company it's your only advertising. When people think of your product—whatever kind of food it may be—they picture the package it comes in "

Mark Greene, Pecos Design, New York

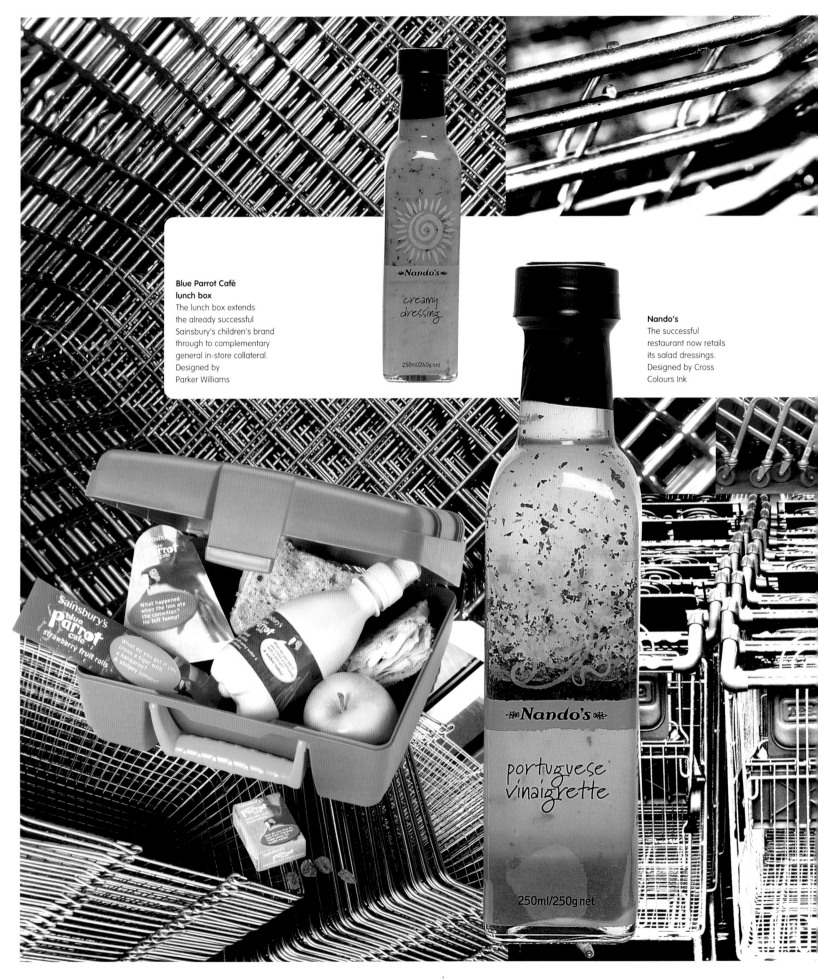

Blue Parrot Café
lunch box
The lunch box extends
the already successful
Sainsbury's children's brand
through to complementary
general in-store collateral.
Designed by
Parker Williams

Nando's
The successful
restaurant now retails
its salad dressings.
Designed by Cross
Colours Ink

One of the often-cited business objectives for
companies' brands—extension into other markets—
can be achieved by taking the branded packaging
for one set of food products and moving it into new
areas. Parker Williams' work on the Blue Parrot Café
children's range (see page 113) for UK supermarket
giant Sainsbury's is typical of this, having been taken
further into general in-store collateral and new
products including shampoos and, more logically,
a lunch box. >>>>>>

There are strong opportunities for cross-branding between different food products, as Michael Coleman, vice president of Chicago's Source Design, explains: "Co-branding extends the reach and appeal of a brand by adding other brands to the mix. You end up with things like Reese's and Hershey's candies coming together. At some point you ask: 'Which brand am I actually buying?' It's a great way for companies to piggy-back on the awareness and interest of other brands. But the brand values of both parties must be carefully matched."

Well-designed and branded packaging also has a part to play in the foodie, lifestyle aspirations of consumers. The movement is toward "kitchen art," where well-heeled 21st-century kitchens are becoming hubs of social activity—open-plan, multifunctional areas for more than just cooking, where attractive product may be consciously displayed as lifestyle branding choices. This trend means that people want to surround themselves with sufficiently aspirational food and drink brands in the same way as they may choose clothing labels to

reflect their social status. As Nita Rollins, vice president of marketing intelligence at Fitch: Worldwide in Ohio, puts it: "Under some spell cast by Nigella Lawson, Martha Stewart, and Emeril Lagasse, the upper-middle classes are busy staging great gustatory theater. They've turned their kitchens into—bar none—the sexiest rooms in their ever-expanding abodes. It's not that the formal dining room has been scratched, more that the kitchen becomes the focus of the most ritualistic social behavior."

If the kitchen itself is becoming sexier, both as a functional place and a social space, and features expensive appliances and implements from leading manufacturers, then there is a concomitant need for food products that live up to those high standards. Here, food packaging designers have their part to play in creating packaging that matches up to the lofty, aspirational ideals of the 21st-century kitchen.

>>>>>>

Belazu
Where kitchens are increasingly social hubs, theaters of gastronomy, attractive labels are put on show as lifestyle labels. Designed by Turner Duckworth

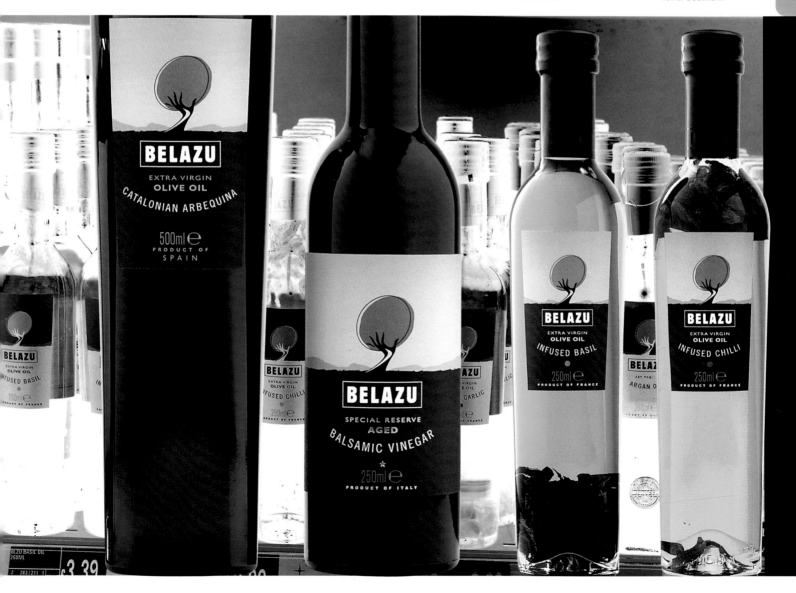

It seems that for designers, then, the opportunities for the best branding work often lie in the sort of premium products that fit the new lifestyle aesthetics of the post-millennial kitchen and home, because branding here is simply required to be visually outstanding. It's also probably fair to say that agencies that don't deal solely in packaging are perhaps best placed to create distinctive branding. Domenic Lippa of London's Lippa Pearce argues that the fact that his firm is not a packaging specialist increases the opportunity to produce distinguished packaging designs and branding for food products. "As a company, we come at a brief from a broader range of social or cultural disciplines. Because we're not reliant on doing loads of packaging, the clients that come to us tend to have very good product."

This, it seems, is the key: good design and distinctive branding follow naturally from a good product. And whether new, old, relaunched, rebranded, or redesigned, if the product isn't up to scratch, it doesn't matter what you do with the design and branding. In this context, Michael Coleman mentions advertising legend William Bernbach's maxim that "the fastest way to kill a bad product is with good advertising," explaining: "The idea is the same and the contention holds true for packaging. Great packaging can arrest, inform, and engage, but ultimately it is the brand that relates and persuades. And a brand is much more than the package, the product, or the logo. A great package for a mediocre product can drive initial trial, but loyalty only follows if the product delivers on a clearly defined brand promise that is valued and valuable."

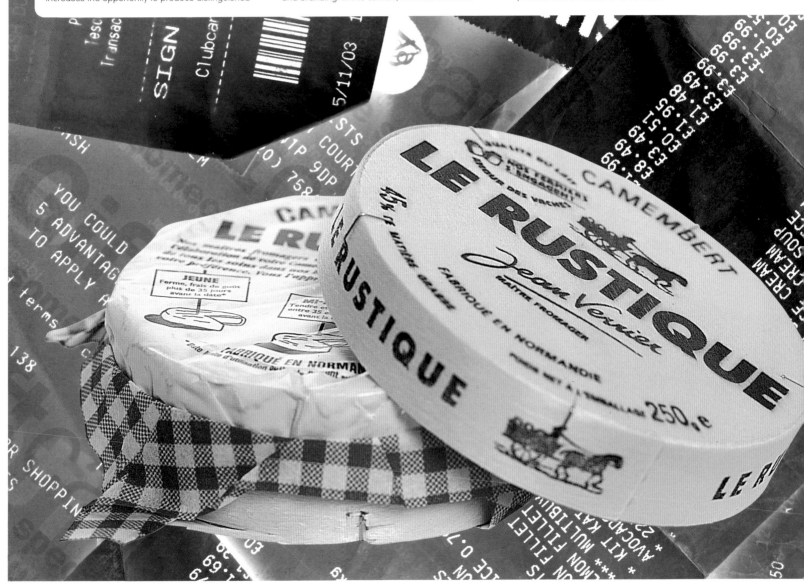

Domenic Lippa concludes: "No matter how good a packaging designer you are, if you haven't got a good product, you're basically just covering over the cracks. That's the most important thing."

left to right

Le Rustique
Rococo Artisan Bar

Consumers pay premium prices for luxury goods packaged to cater to aspirations as much as to functional requirements. Designers unknown

Softly acclaimed bars are made using our own blend of organic cocoa beans and recipes which ...d in our tiny chocolate kitchens. These overlook ...of the 18th Century Vauxhall Pleasure ...also known as The Rococo Gardens. The ...an antique design, reflecting the bar wrapper. ...dark chocolate has a 65% cocoa content and ...rly high percentage of cocoa butter (the only ...which gives the bars their silky texture. The ...the chocolate is robust enough to complement ...al flavours without overpowering them. Only ...purest and where possible organic ingredients ...to flavour the chocolate. Here is our current ...vours which varies according to the season.

%) Black Pepper - Caramelised
- Cardamon - Chilli Pepper
cha Java - Crystallised Ginger
Tea - Lavender - Orange Confite
d Geranium - Pink Pepper
- Tarragon
mas... Gold, Frankincense and Myrrh
berry - (Christmas Pudding)
%) Cinnamon - Sea Salt - Rose
ardamom (at Christmas... Cranberry and

our Website at www.rococochocolates.com
for further information

Rococo Chocolates, 321 King's Road
Chelsea, London SW3 5EP
Telephone: 020 7352 5857

Desirable packets

"Desirable packets" presents a showcase of the best in food and drink packaging design from the US and Europe. We've broken it down into four sections: "premium products" is where the awards tend to go—it's in these well-heeled niches that food packaging design tends to flourish; but there is also plenty to admire in the work carried out for giant brands in "global domination," while "own label" has improved vastly in the past few years; "shelf life" features those products that don't fit easily into any particular category, but are still worth a look... suck 'em and see.

premium products

for the discerning palate and wallet

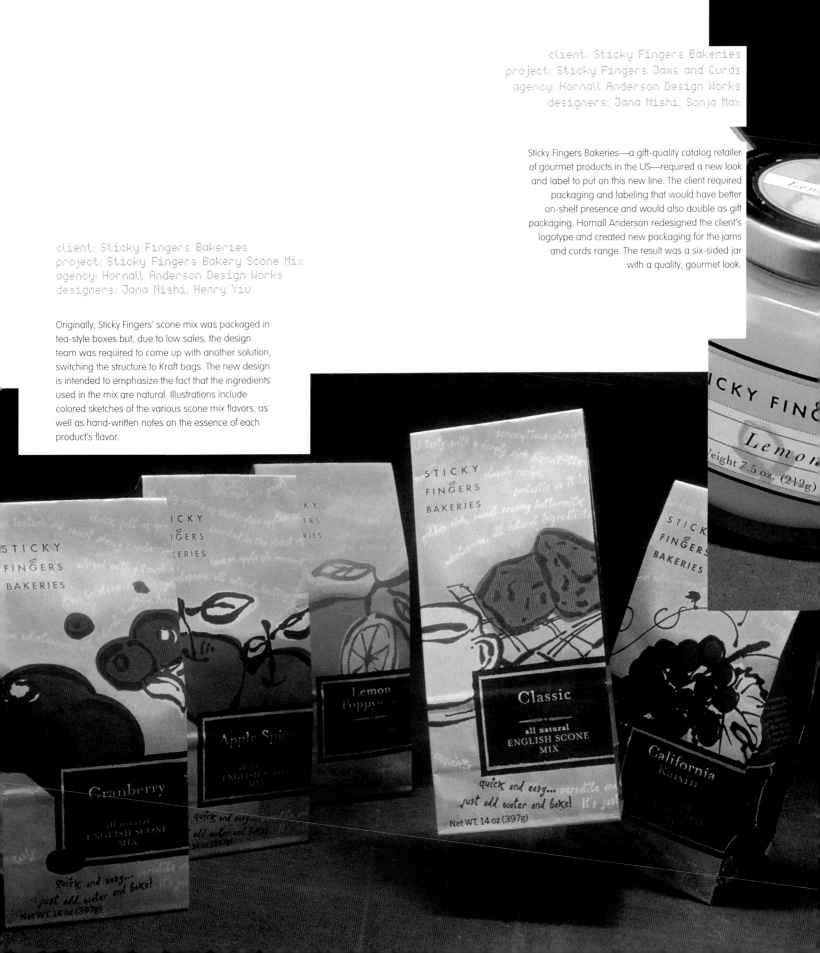

client: Sticky Fingers Bakeries
project: Sticky Fingers Jams and Curds
agency: Hornall Anderson Design Works
designers: Jana Nishi, Sonja Max

Sticky Fingers Bakeries—a gift-quality catalog retailer of gourmet products in the US—required a new look and label to put on this new line. The client required packaging and labeling that would have better on-shelf presence and would also double as gift packaging. Hornall Anderson redesigned the client's logotype and created new packaging for the jams and curds range. The result was a six-sided jar with a quality, gourmet look.

client: Sticky Fingers Bakeries
project: Sticky Fingers Bakery Scone Mix
agency: Hornall Anderson Design Works
designers: Jana Nishi, Henry Yiu

Originally, Sticky Fingers' scone mix was packaged in tea-style boxes but, due to low sales, the design team was required to come up with another solution, switching the structure to Kraft bags. The new design is intended to emphasize the fact that the ingredients used in the mix are natural. Illustrations include colored sketches of the various scone mix flavors, as well as hand-written notes on the essence of each product's flavor.

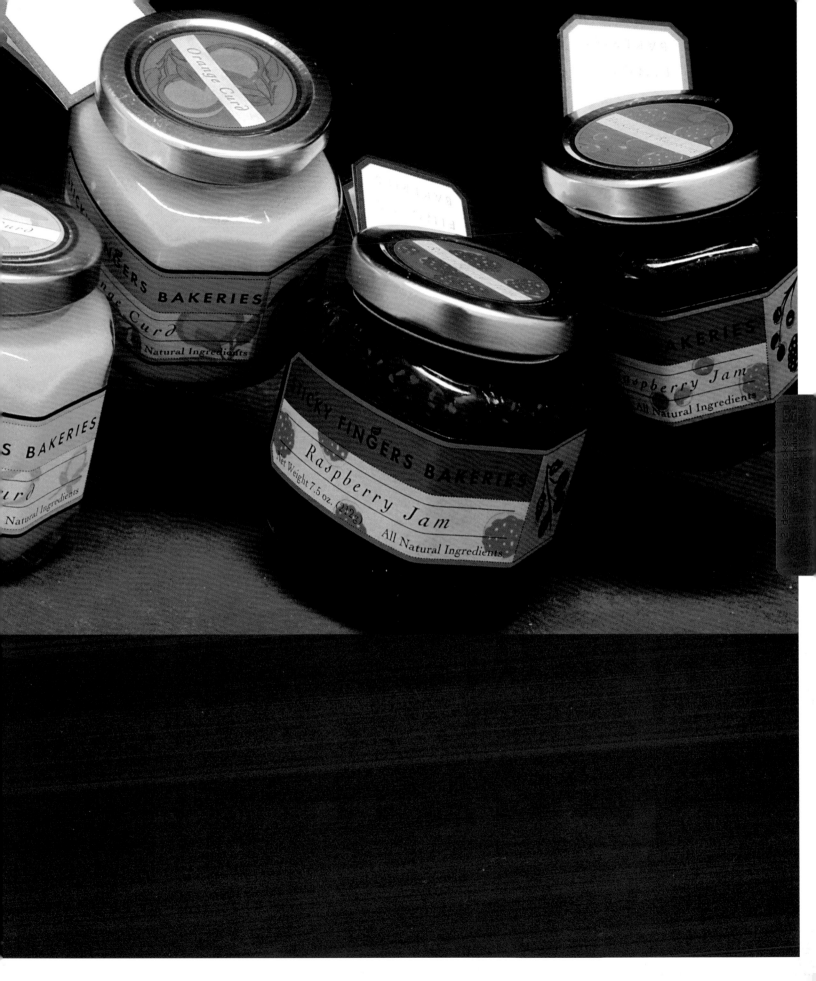

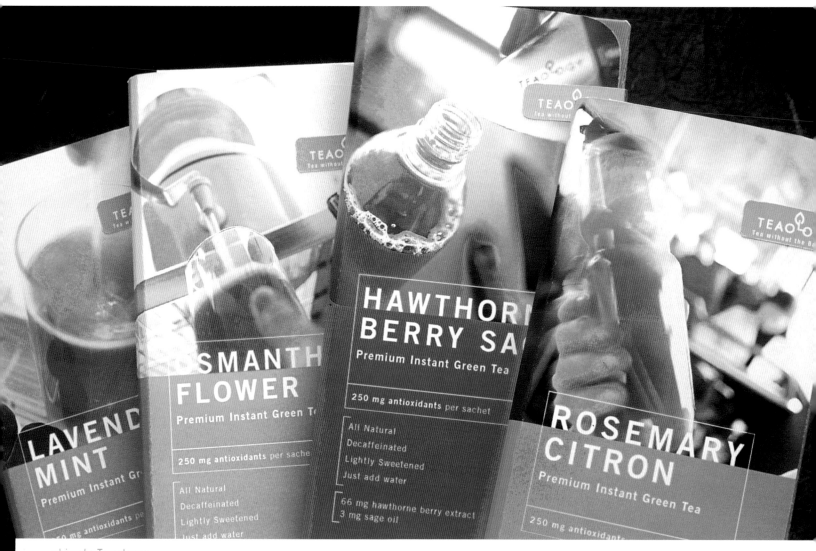

client: Teaology
project: Teaology
agency: Hornall Anderson Design Works
designers: Jana Nishi, Mary Chin Hutchinson, Sonja Max

When Teaology—a US producer of healthy, anti-oxidant-rich, premium instant tea—coined the strapline "Tea without the baggage," it needed distinctive packaging to match the product's promise in an overcrowded market. Hornall Anderson incorporated photographic still-life images. "As opposed to the whimsical illustrations seen on other brands," Christina Arbini comments, "it helps set the mood and create an ambience around the tea flavors." The photography is also intended to demonstrate the ease of use of the product.

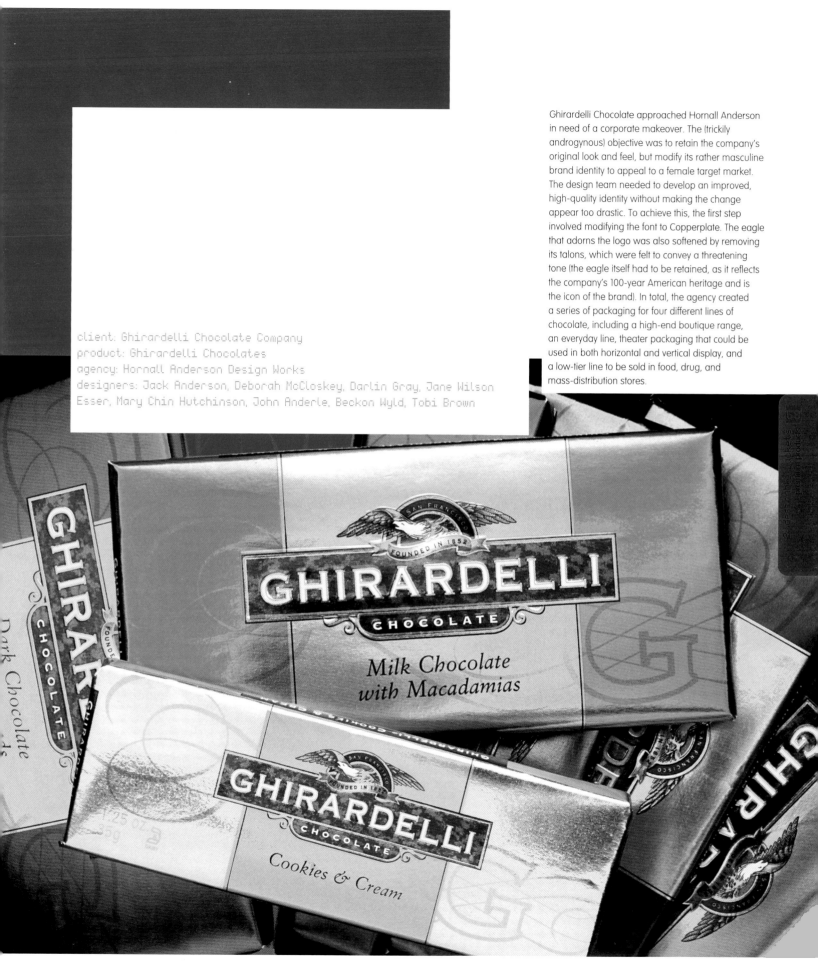

client: Ghirardelli Chocolate Company
product: Ghirardelli Chocolates
agency: Hornall Anderson Design Works
designers: Jack Anderson, Deborah McCloskey, Darlin Gray, Jane Wilson
Esser, Mary Chin Hutchinson, John Anderle, Beckon Wyld, Tobi Brown

Ghirardelli Chocolate approached Hornall Anderson in need of a corporate makeover. The (trickily androgynous) objective was to retain the company's original look and feel, but modify its rather masculine brand identity to appeal to a female target market. The design team needed to develop an improved, high-quality identity without making the change appear too drastic. To achieve this, the first step involved modifying the font to Copperplate. The eagle that adorns the logo was also softened by removing its talons, which were felt to convey a threatening tone (the eagle itself had to be retained, as it reflects the company's 100-year American heritage and is the icon of the brand). In total, the agency created a series of packaging for four different lines of chocolate, including a high-end boutique range, an everyday line, theater packaging that could be used in both horizontal and vertical display, and a low-tier line to be sold in food, drug, and mass-distribution stores.

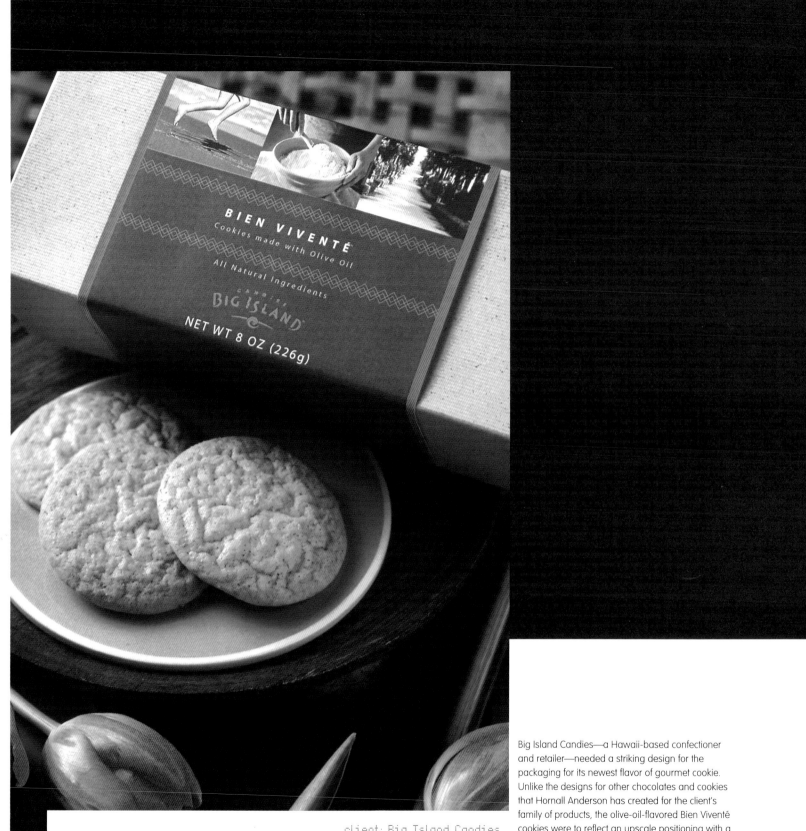

BIEN VIVENTÉ
Cookies made with Olive Oil
All Natural Ingredients
CANDIES
BIG ISLAND
NET WT 8 OZ (226g)

client: Big Island Candies
project: Big Island Candies Olive Oil Cookies
agency: Hornall Anderson Design Works
designers: Jack Anderson, Katy Saito, Sonja Max, Alan Copeland

Big Island Candies—a Hawaii-based confectioner and retailer—needed a striking design for the packaging for its newest flavor of gourmet cookie. Unlike the designs for other chocolates and cookies that Hornall Anderson has created for the client's family of products, the olive-oil-flavored Bien Viventé cookies were to reflect an upscale positioning with a distinctly Italian theme. To differentiate them from other products, snippets of photographs were applied depicting the lifestyle of Italy. An organic color palette of olive green and terracotta orange completes the overall package design, yielding a fresh face for this new specialty line of cookies.

client: Rocky Mountain Chocolate Factory
project: Rocky Mountain Chocolate Factory packaging
agency: Hornall Anderson Design Works
designers: Larry Anderson, Gretchen Cook, Jay Hilburn, Kaye Farmer, Andrew Wicklund

Melted chocolate swirling in a copper kettle—reminiscent of the old-fashioned way in which this brand still manufactures its product—was the inspiration for Colorado-based Rocky Mountain's new packaging designs. A gourmet chocolate and confectionery company, it was felt that the company's previous packaging was too rugged—inappropriate for its high-end, quality gift positioning. The new packaging highlights Rocky Mountain's tone-on-tone, swirl texture and is applied to each piece of packaging within the client's line.

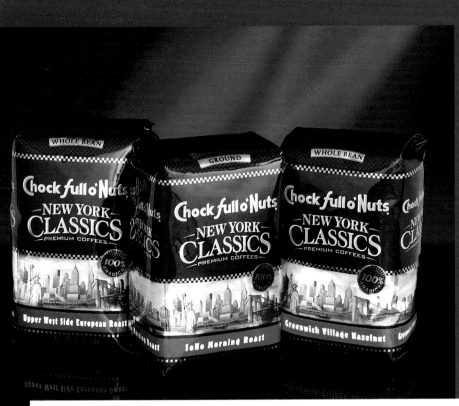

client: Sara Lee Coffee and Tea
project: Chock full o'Nuts New York Classics
agency: Lipson Alport Glass & Associates
designers: Rob Swan, Walter Perlowski

Lipson Alport Glass & Associates was charged with creating packaging for a premium-tier, bagged ground and whole-bean coffee line that would make the most of Chock full o'Nuts' New York positioning. Metallic bags were used to create a very rich illustration that is "idealized New York," says creative director Rob Swan. The gold-on-gold effect is a premium cue, while the use of Big Apple imagery complements the name. The flavor names were also enhanced to give them "a distinctly New York spin." Core equities from the previous packaging were used to avoid alienating existing users, while also extending the franchise.

When Seagram Americas purchased a small distillery in Kentucky, they acquired more than five generations of Bulleit family history. Bulleit Bourbon is marketed as a "Frontier whiskey" with an ad slogan that reads, "When men were men and whiskey was bourbon." Targeting a wide swathe of the sophisticated whiskey market, but not wanting to become a "preciously perfect or Jim Beam knock-off brand," Bulleit Bourbon was created for Seagram as authentic, traditional bourbon. Sandstrom's design reflects the frontier positioning of the advertising, and features a unique shape and raised letters similar to 19th-century whiskeys. The packaging was modeled on a liquor bottle found in a Portland antique shop, and the label is intentionally applied misaligned to hint at the handcrafted quality of the product. The neck label contains a personal message from Tom Bulleit, the fifth-generation owner of Bulleit Distilling Company.

client: Seagram Americas
project: Bulleit Bourbon
agency: Sandstrom Design
designers: Steve Sandstrom, Kathy Middleton

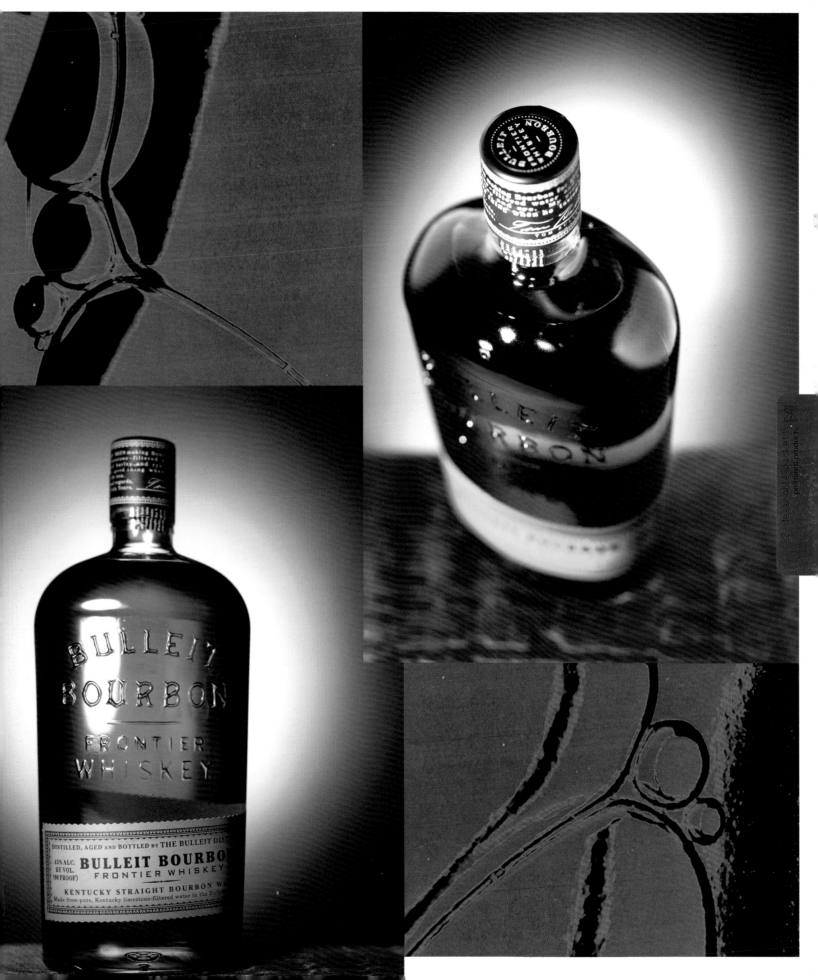

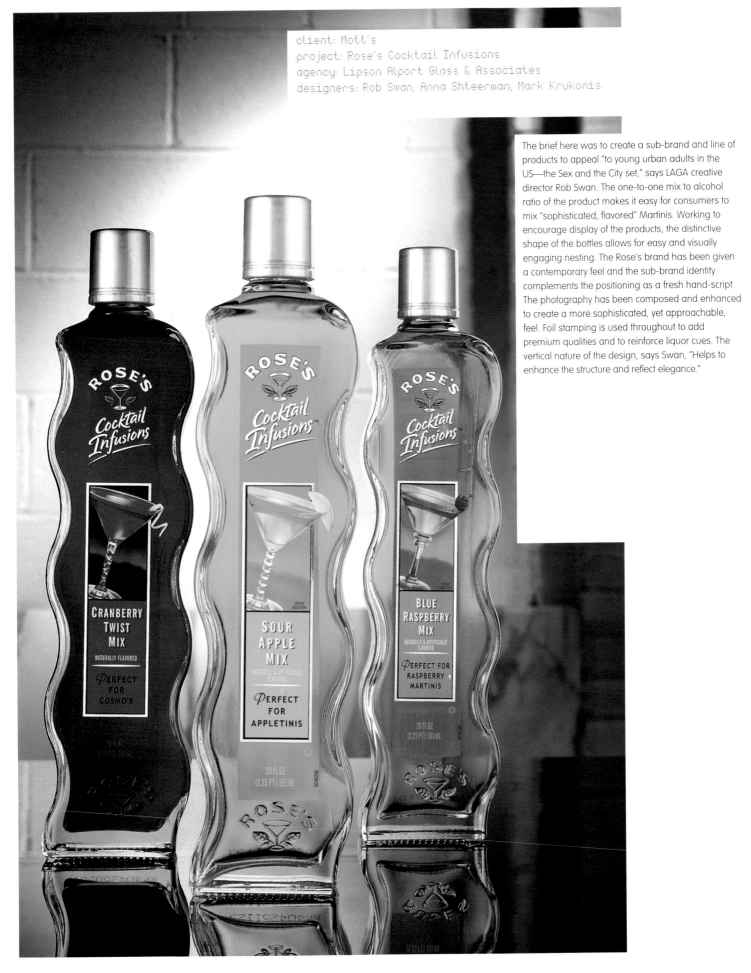

client: Mott's
project: Rose's Cocktail Infusions
agency: Lipson Alport Glass & Associates
designers: Rob Swan, Anna Shteerman, Mark Krukonis

The brief here was to create a sub-brand and line of products to appeal "to young urban adults in the US—the Sex and the City set," says LAGA creative director Rob Swan. The one-to-one mix to alcohol ratio of the product makes it easy for consumers to mix "sophisticated, flavored" Martinis. Working to encourage display of the products, the distinctive shape of the bottles allows for easy and visually engaging nesting. The Rose's brand has been given a contemporary feel and the sub-brand identity complements the positioning as a fresh hand-script. The photography has been composed and enhanced to create a more sophisticated, yet approachable, feel. Foil stamping is used throughout to add premium qualities and to reinforce liquor cues. The vertical nature of the design, says Swan, "Helps to enhance the structure and reflect elegance."

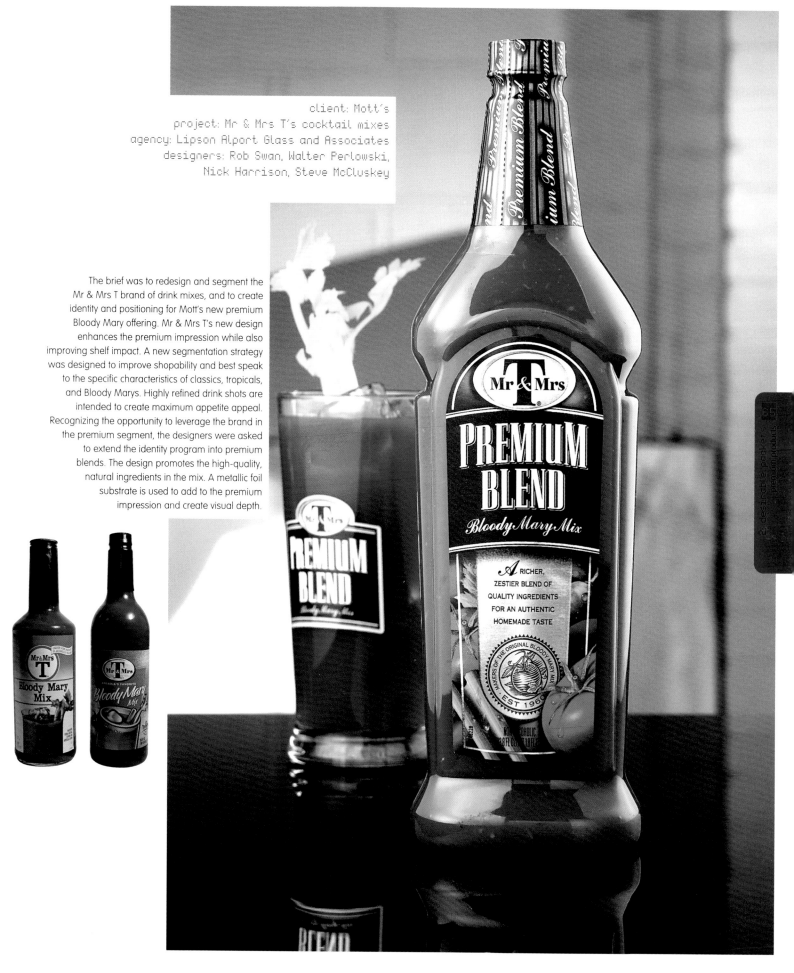

client: Mott's
project: Mr & Mrs T's cocktail mixes
agency: Lipson Alport Glass and Associates
designers: Rob Swan, Walter Perlowski,
Nick Harrison, Steve McCluskey

The brief was to redesign and segment the Mr & Mrs T brand of drink mixes, and to create identity and positioning for Mott's new premium Bloody Mary offering. Mr & Mrs T's new design enhances the premium impression while also improving shelf impact. A new segmentation strategy was designed to improve shopability and best speak to the specific characteristics of classics, tropicals, and Bloody Marys. Highly refined drink shots are intended to create maximum appetite appeal. Recognizing the opportunity to leverage the brand in the premium segment, the designers were asked to extend the identity program into premium blends. The design promotes the high-quality, natural ingredients in the mix. A metallic foil substrate is used to add to the premium impression and create visual depth.

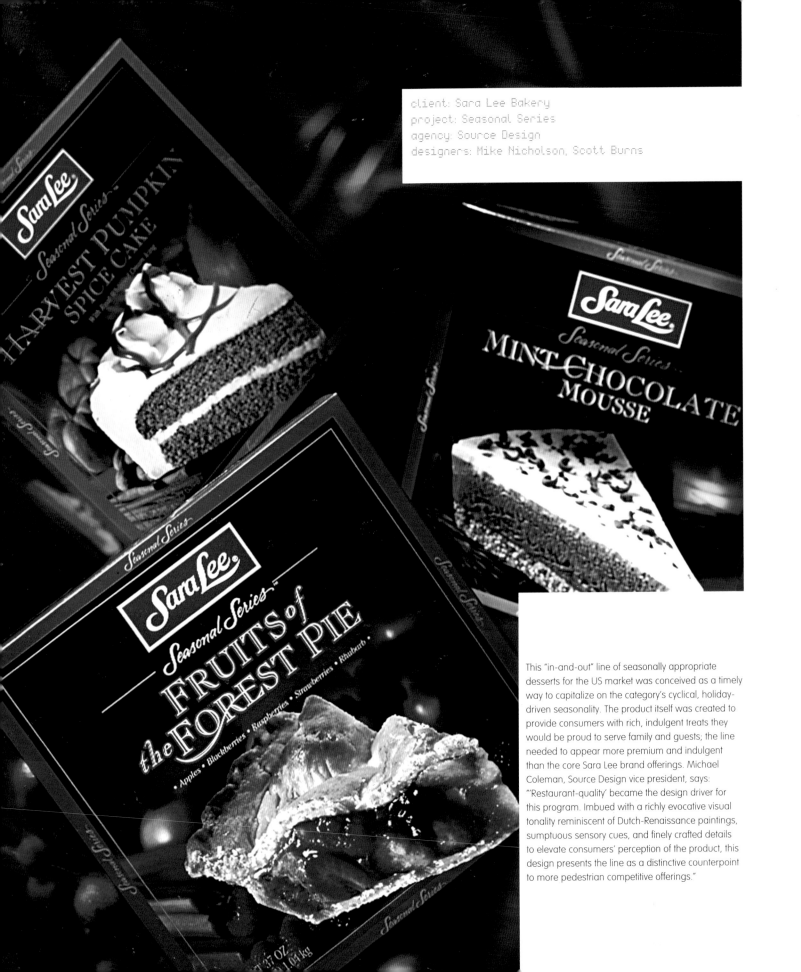

client: Sara Lee Bakery
project: Seasonal Series
agency: Source Design
designers: Mike Nicholson, Scott Burns

This "in-and-out" line of seasonally appropriate desserts for the US market was conceived as a timely way to capitalize on the category's cyclical, holiday-driven seasonality. The product itself was created to provide consumers with rich, indulgent treats they would be proud to serve family and guests; the line needed to appear more premium and indulgent than the core Sara Lee brand offerings. Michael Coleman, Source Design vice president, says: "'Restaurant-quality' became the design driver for this program. Imbued with a richly evocative visual tonality reminiscent of Dutch-Renaissance paintings, sumptuous sensory cues, and finely crafted details to elevate consumers' perception of the product, this design presents the line as a distinctive counterpoint to more pedestrian competitive offerings."

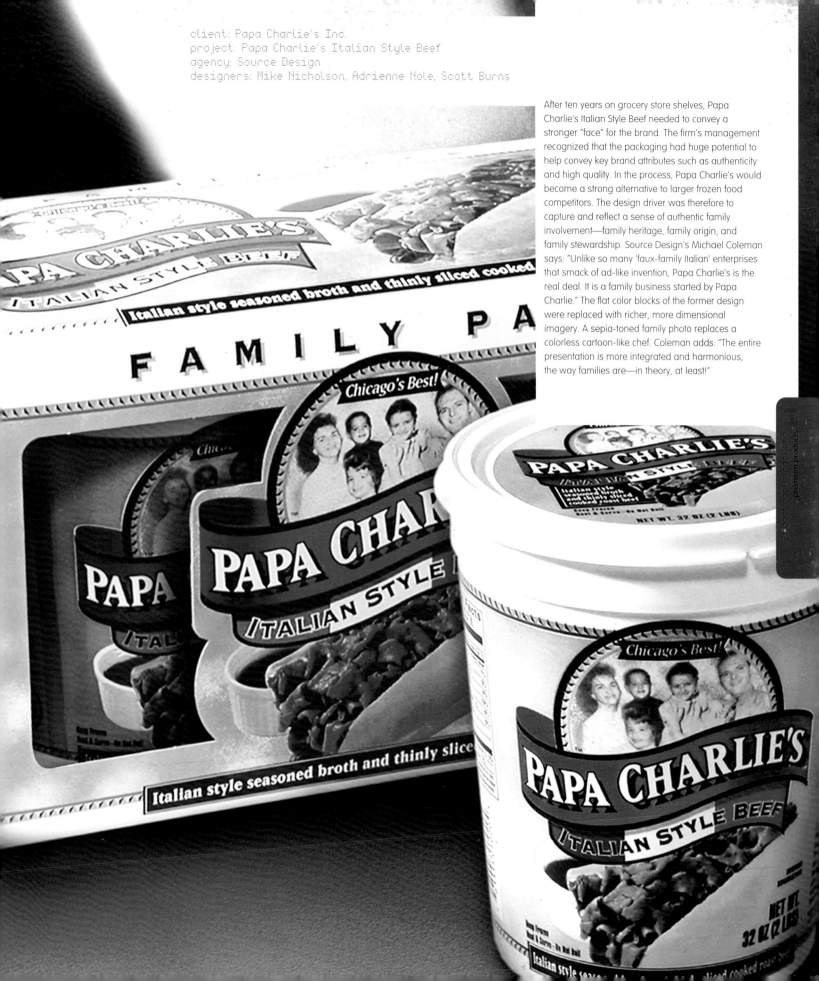

client: Papa Charlie's Inc.
project: Papa Charlie's Italian Style Beef
agency: Source Design
designers: Mike Nicholson, Adrienne Nole, Scott Burns

After ten years on grocery store shelves, Papa Charlie's Italian Style Beef needed to convey a stronger "face" for the brand. The firm's management recognized that the packaging had huge potential to help convey key brand attributes such as authenticity and high quality. In the process, Papa Charlie's would become a strong alternative to larger frozen food competitors. The design driver was therefore to capture and reflect a sense of authentic family involvement—family heritage, family origin, and family stewardship. Source Design's Michael Coleman says: "Unlike so many 'faux-family Italian' enterprises that smack of ad-like invention, Papa Charlie's is the real deal. It is a family business started by Papa Charlie." The flat color blocks of the former design were replaced with richer, more dimensional imagery. A sepia-toned family photo replaces a colorless cartoon-like chef. Coleman adds: "The entire presentation is more integrated and harmonious, the way families are—in theory, at least!"

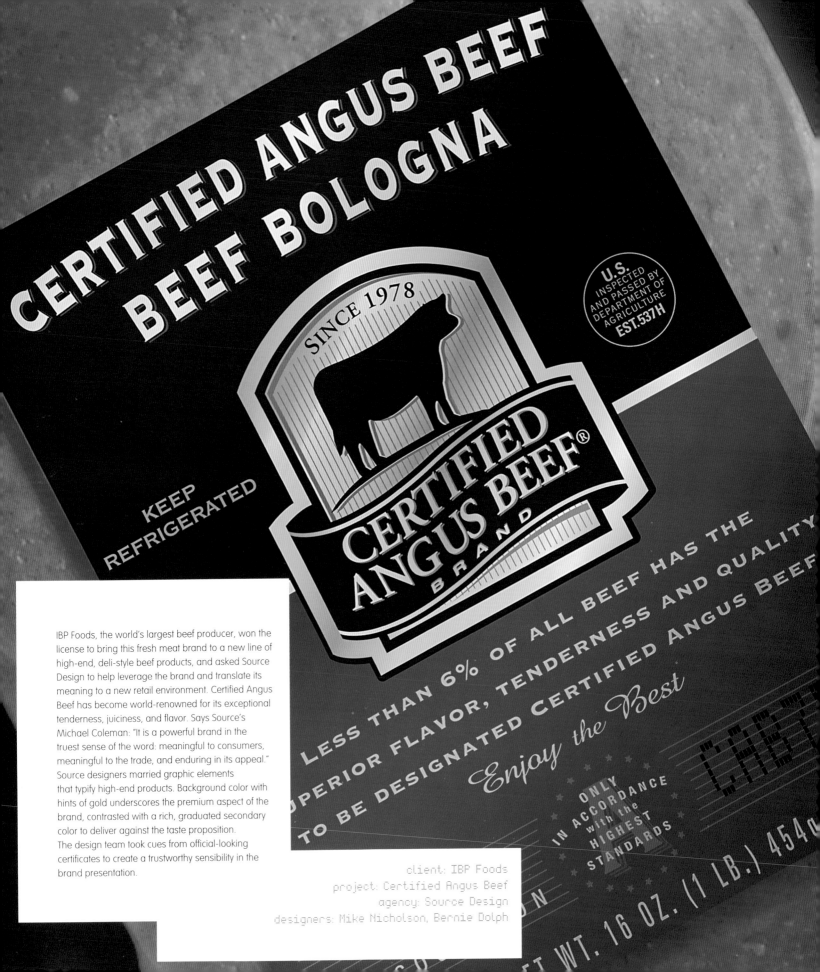

CERTIFIED ANGUS BEEF BEEF BOLOGNA

SINCE 1978

U.S. INSPECTED AND PASSED BY DEPARTMENT OF AGRICULTURE EST.537H

KEEP REFRIGERATED

CERTIFIED ANGUS BEEF® BRAND

LESS THAN 6% OF ALL BEEF HAS THE SUPERIOR FLAVOR, TENDERNESS AND QUALITY TO BE DESIGNATED CERTIFIED ANGUS BEEF

Enjoy the Best

ONLY IN ACCORDANCE with the HIGHEST STANDARDS

16 OZ. (1 LB.) 454g

IBP Foods, the world's largest beef producer, won the license to bring this fresh meat brand to a new line of high-end, deli-style beef products, and asked Source Design to help leverage the brand and translate its meaning to a new retail environment. Certified Angus Beef has become world-renowned for its exceptional tenderness, juiciness, and flavor. Says Source's Michael Coleman: "It is a powerful brand in the truest sense of the word: meaningful to consumers, meaningful to the trade, and enduring in its appeal." Source designers married graphic elements that typify high-end products. Background color with hints of gold underscores the premium aspect of the brand, contrasted with a rich, graduated secondary color to deliver against the taste proposition. The design team took cues from official-looking certificates to create a trustworthy sensibility in the brand presentation.

client: IBP Foods
project: Certified Angus Beef
agency: Source Design
designers: Mike Nicholson, Bernie Dolph

Pentagram was given the brief to design a new identity based on an existing logotype that would revitalize the Columbus brand identity and broaden its appeal. Designer Jackie Foshaug-Astle responded by giving the Columbus illustration more personality, using engraving to refer to Columbus' historical context. She also worked with a family of classical-traditional typefaces to create the logotype and its applications. "All in all, we were going for a quality look reflecting Italian American heritage—something based on the roots and spirit of the existing company," she says.

client: Columbus Salame Company
project: Columbus Salame packaging
agency: Pentagram, San Francisco
designer: Jackie Foshaug-Astle

COLUMBUS SALAME

COLUMBUS
BUON
GUSTO

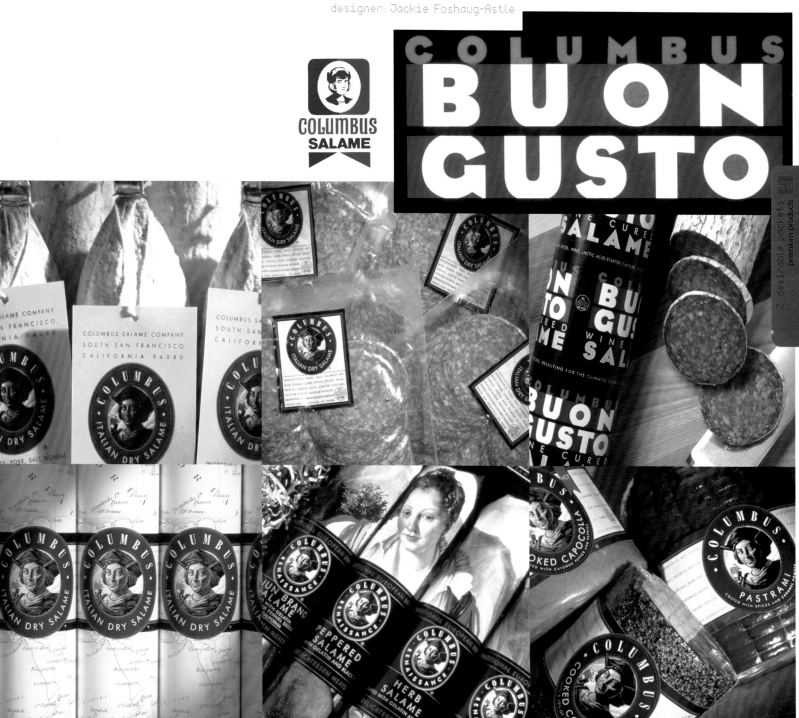

2 desirable packets
premium products
69

client: North Coast Brewing Company
project: Red Seal Ale redesign
agency: Colored Horse
designer: Theresa Whitehill

North Coast Brewing Company, a micro-brewery in northern California, wanted to revamp its designs as it began to grow. Its award-winning Red Seal Ale was the first of a number of a projects that Theresa Whitehill has worked on for the company. Whitehill initially art-directed a redesign of the company's logo, coming up with the whale-tail design that the company has stuck with ever since. She also made better use of the pen-and-ink seal illustration from the original packaging, positioning it with an intense red stripe above and a deep, four-color black as the background. Whitehill recalls: "I drove five hours each way to the print checks to make sure they had captured the color. The seal is a great motif because the client is on the north coast of California, where there is a lot of wildlife and ocean life."

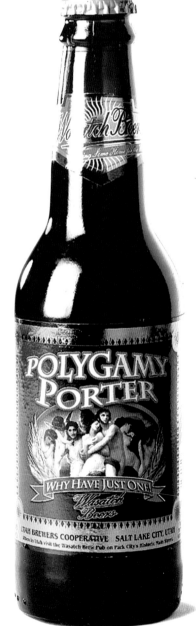

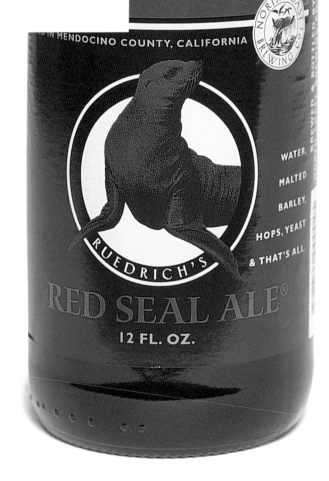

client: Wasatch Brewing Company
project: Polygamy Porter Beers
agency: Ajax Design
designer: Art Burrows

Bud, Coors, and Michelob may have a stranglehold on the beer market in the US, but micro-brewer Wasatch tends to challenge more than just the hegemony of these über-brands. Designing beer packaging for the formerly dry state of Utah was always going to be an interesting challenge for Ajax; Wasatch takes pride in a certain subversive slant for its packaging in this most conservative of US states, where obtaining and drinking beer still involves a fairly Kafkaesque process. Preaching to a small (but very much converted) audience, Ajax's irreverent, Mormon-baiting design includes the strapline "Why have just one?"

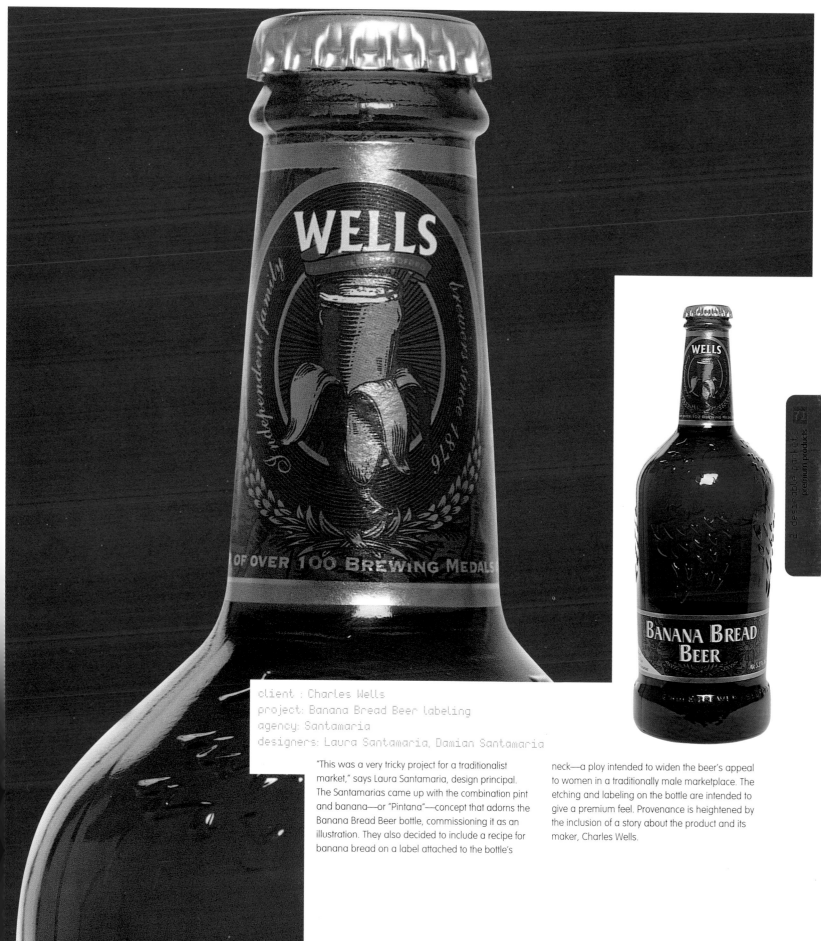

client : Charles Wells
project: Banana Bread Beer labeling
agency: Santamaria
designers: Laura Santamaria, Damian Santamaria

"This was a very tricky project for a traditionalist market," says Laura Santamaria, design principal. The Santamarias came up with the combination pint and banana—or "Pintana"—concept that adorns the Banana Bread Beer bottle, commissioning it as an illustration. They also decided to include a recipe for banana bread on a label attached to the bottle's neck—a ploy intended to widen the beer's appeal to women in a traditionally male marketplace. The etching and labeling on the bottle are intended to give a premium feel. Provenance is heightened by the inclusion of a story about the product and its maker, Charles Wells.

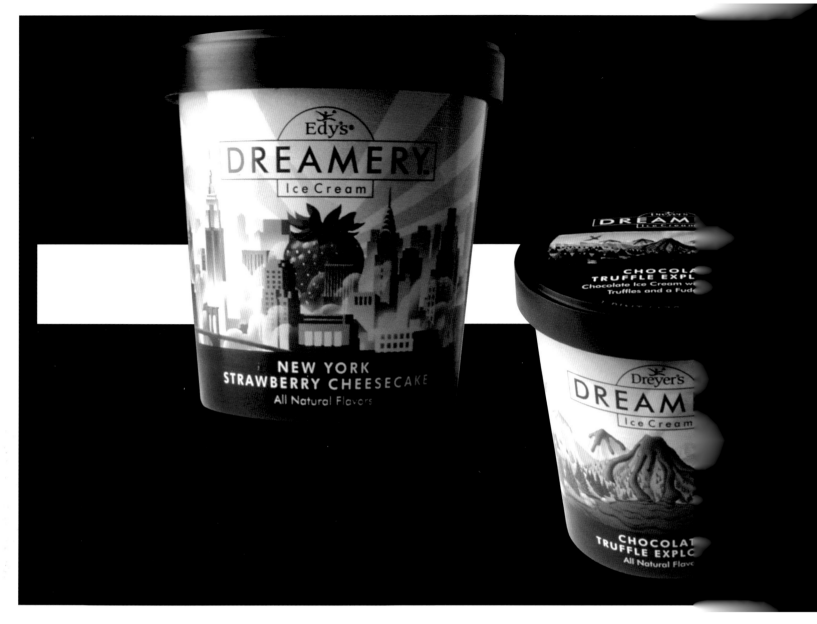

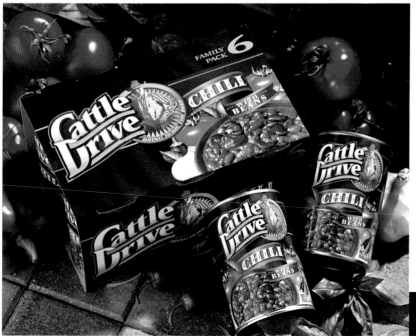

client: Castleberry/Snow
project: Cattle Drive
agency: Berni Design and Marketing
designer: Stuart Berni

Castleberry/Snow's launch of a new premium chili required a new brand communication and packaging program. Berni devised both the brand name and a memorable labeling concept that highlights hot colors and quality ingredients, while tapping into an archetypal element of US mythology—the cowboy.

client: Dreyer's
project: Dreamery Ice Cream
agency: Pentagram, San Francisco
designers: Kit Hinrichs, Brian Jacobs

Dreyer's commissioned Pentagram to design the packaging for this ice cream product. The new line was created to establish Dreyer's in the crowded super-premium ice cream market, competing with established brands such as Häagen-Dazs and Ben & Jerry's. Traditionally, the company's products had been in the low-cost bulk market. The name "Dreamery" is intended to give a "mystical quality" to the product as an indulgent adult ice cream. Each flavor features an illustration by different artists using landscapes and incorporating the ingredients as a "dreamland of flavor". Since the launch in 1999, the line of ice creams has expanded to include 21 flavors.

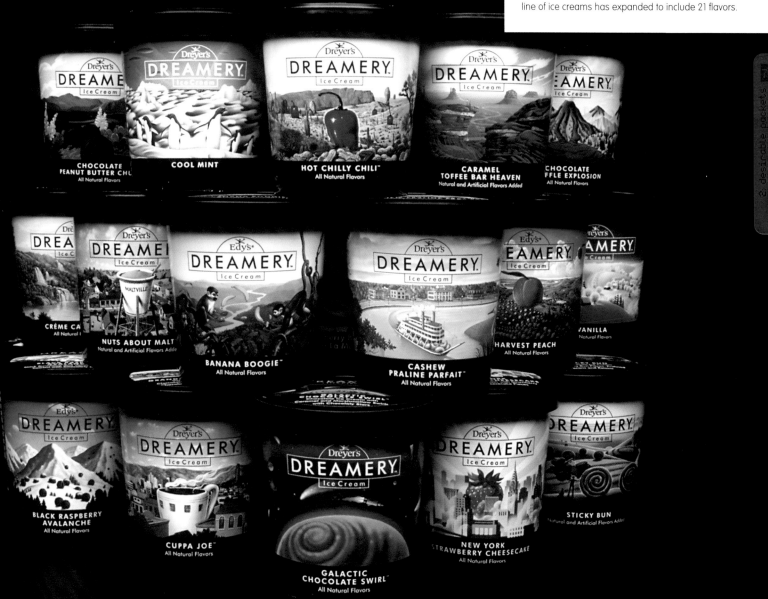

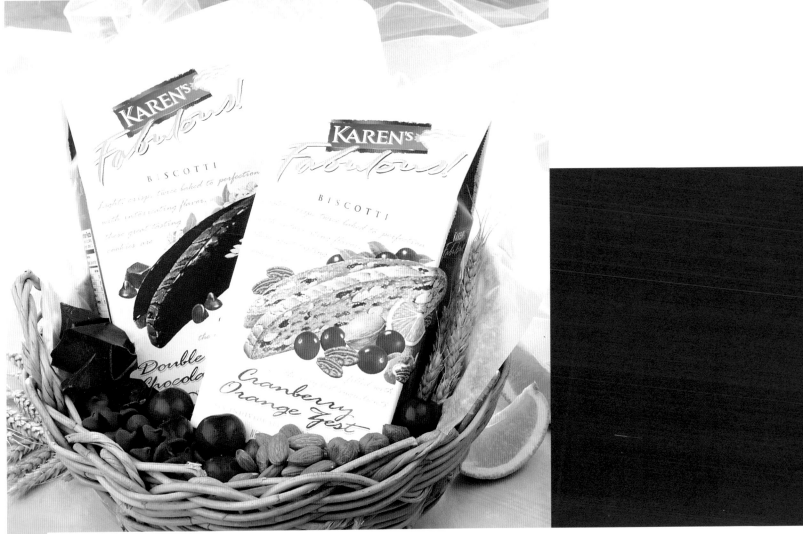

client: Karen's Fabulous
project: Karen's Fabulous
agency: Berni Design and Marketing
designer: Stuart Berni

Karen's Fabulous, a premium biscotti line, required updated packaging and more competitive market positioning. Berni developed an emotive packaging system designed to whet the consumer's appetite and appeal to the eye, while also highlighting quality ingredients. "The visuals perfectly portray our product," says Jerry O'Donnell, Karen's Fabulous general manager, "and the package jumps off the shelf."

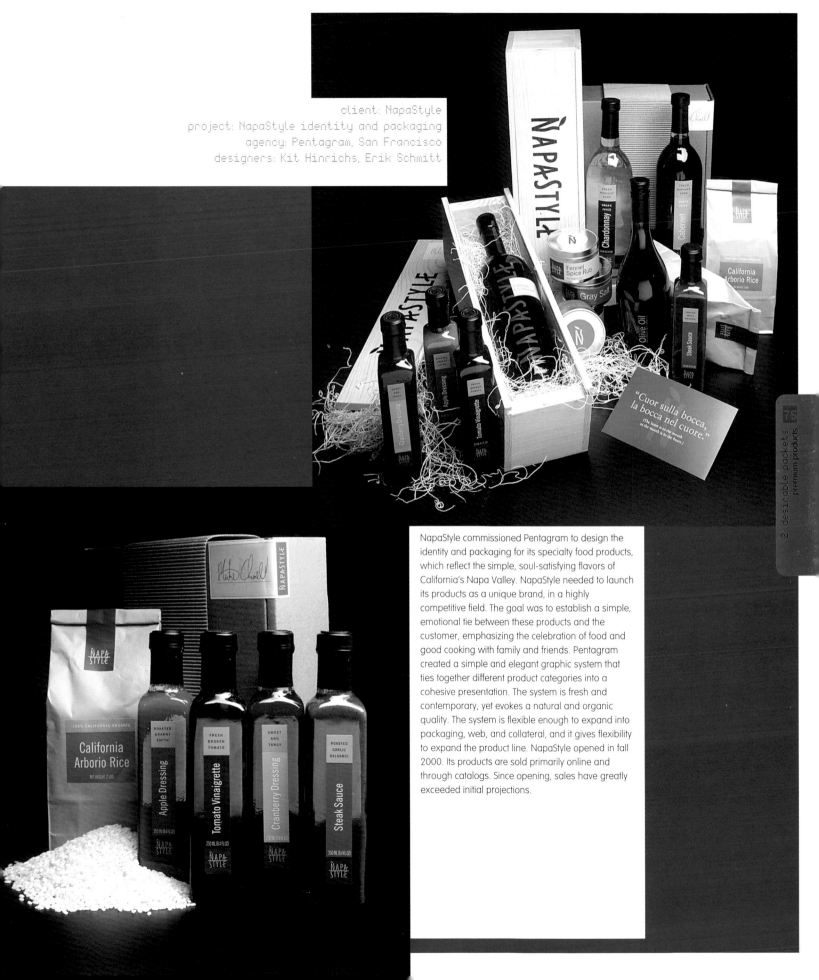

"Cuor sulla bocca,
la bocca nel cuore."
(The heart is in the mouth
as the mouth is in the heart.)

2 desirable packets
premium products

NapaStyle commissioned Pentagram to design the identity and packaging for its specialty food products, which reflect the simple, soul-satisfying flavors of California's Napa Valley. NapaStyle needed to launch its products as a unique brand, in a highly competitive field. The goal was to establish a simple, emotional tie between these products and the customer, emphasizing the celebration of food and good cooking with family and friends. Pentagram created a simple and elegant graphic system that ties together different product categories into a cohesive presentation. The system is fresh and contemporary, yet evokes a natural and organic quality. The system is flexible enough to expand into packaging, web, and collateral, and it gives flexibility to expand the product line. NapaStyle opened in fall 2000. Its products are sold primarily online and through catalogs. Since opening, sales have greatly exceeded initial projections.

client: Germain-Robin
project: Liqueur de Poète brandy labeling
agency: Colored Horse
designer: Theresa Whitehill

GERMAIN - ROBIN

LIQUEUR DE POÈTE

Il vient à l'odorat des effluves
Savors awaken
qui réveillent la langue engourdie;
the sluggish tongue
parfums mûrs
fragrances ripe as a woman's flesh
comme des chairs de femmes
revealing in each fold
révélant dans chaque repli
a secret...
un goût secret...
Fireworks erupting
Papilles réveillées réfutent
along the palate
les limites corporelles,
foretaste of blood's divinity,
un avant-goût de divinité
a delicate human flowering.
éclot la fleur inespérée de l'humain.

Poem
Lydia
Rand

Design
Colored
Horse
Studios

375 ML
25% ALC./VOL.

Brandies from California hand-distiller Germain-Robin have been consumed in the White House since the administration of Jimmy Carter in the 1970s, but, for this new product, the company wanted to move away from the traditionalist, masculine image of the drink to attract a female market. Whitehill used a public-domain image of a bird—cribbed from a medieval manuscript—and a lighter color scheme than is typical in the market. The labeling also features a specially commissioned poem in French, reflecting co-founder Hubert Germain-Robin's Cognac family heritage. The product is intended to be advertised on the Internet and supplied by mail order, meaning that the designer was freed from some of the constraints imposed by making the labeling grocery store- and bar-friendly.

client: Innocent Drinks
project: Juicy Water launch
agency: Coley Porter Bell
designers: Stephen Bell, Bronwen Edwards, Roberta Elliot

As part of a total design review for Innocent (see page 26), Coley Porter Bell created an identity for the brand's new drink, Juicy Water. The brief encompassed the design of the glass bottle, bottle lid, and packaging.

"Every element on the packaging, including the bottle lid, use of icon, and back of pack has been designed to support Innocent's equities and to maximize the Innocent identity," says Stephen Bell, creative director. The copy on the back of the bottle—displayed upside down—explains that by turning the bottle on its head to read the label, the consumer is actually mixing the drink within, ready for serving. This design solution not only draws attention to the use of natural ingredients (the fruit separates from the water because no stabilizers, gums, or concentrates are used), but also allows the consumer to interact with the product. The front-of-bottle label design is fresh, uncluttered, and designed to be consistent with the whole range.

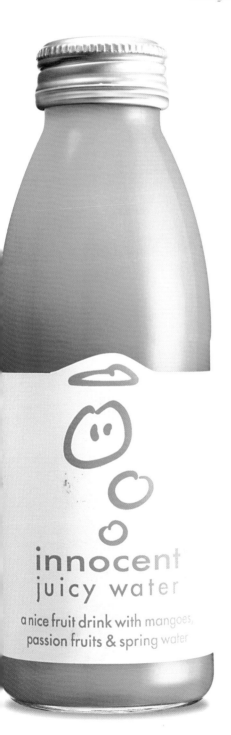

innocent juicy water

a nice fruit drink with mangoes, passion fruits & spring water

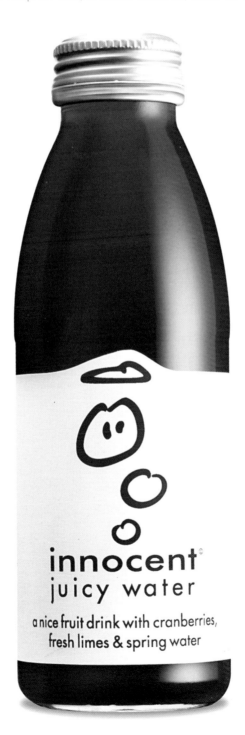

innocent® juicy water

a nice fruit drink with cranberries, fresh limes & spring water

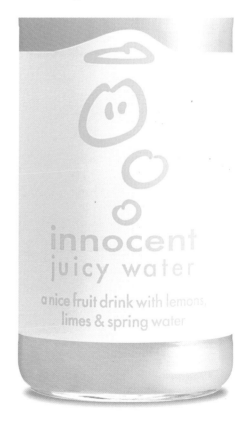

innocent juicy water

a nice fruit drink with lemons, limes & spring water

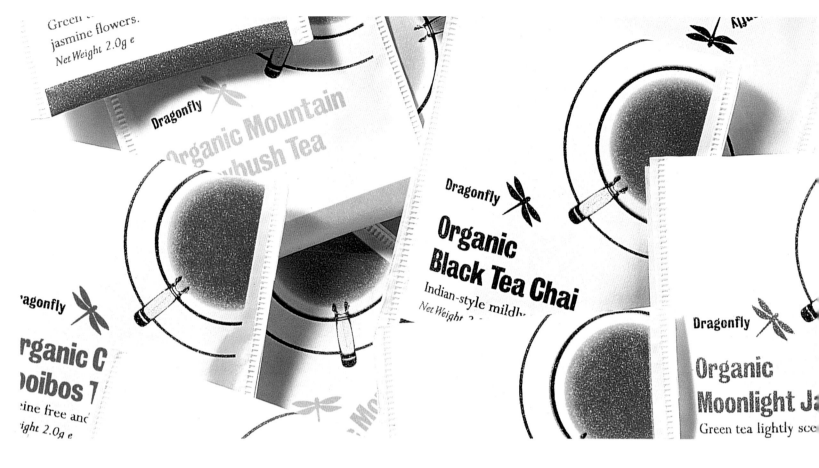

client: Wistbray Limited
project: Dragonfly Teas identity and packaging
agency: Pentagram
designers: David Hillman, Liza Enebeis
photographer: Teresa Hayhurst

Pentagram was invited to create a name, brand identity, and packaging for this range of organic teas. The packaging for the entire range was designed to create a strong impact on the shelf, while differentiating the product from other organic offerings and reflecting Wistbray's quality and heritage. Using clean, clear typography, color-coded to each tea, and the photographic device of wrapping an image around the packaging, the design is intended to give the new teas a powerful presence at point-of-sale. Pentagram's design work for Dragonfly Teas was recognized at the 2001 FAB (Food and Beverage) Awards, where it received a number of awards, including the Best of Show prize for Packaging and Design. Pentagram has since adapted the brand for the US market, using the same packaging, but changing the name to Dragoncloud Teas for regulatory reasons.

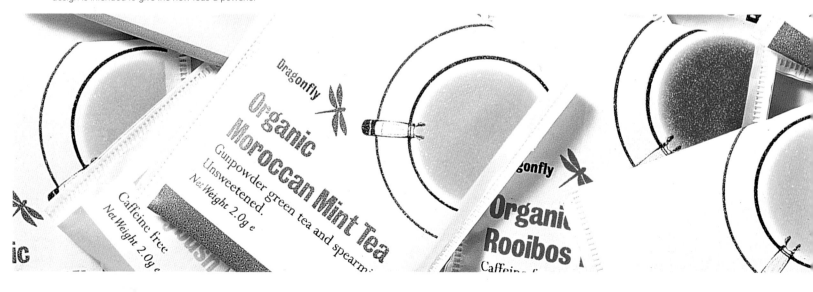

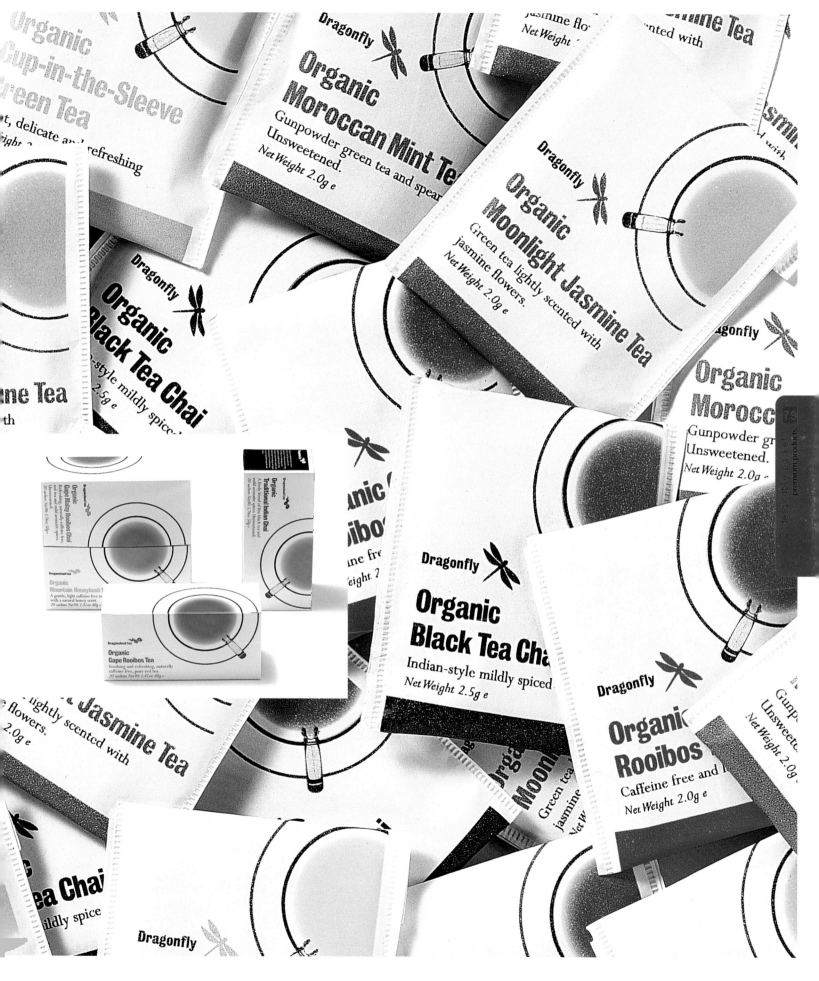

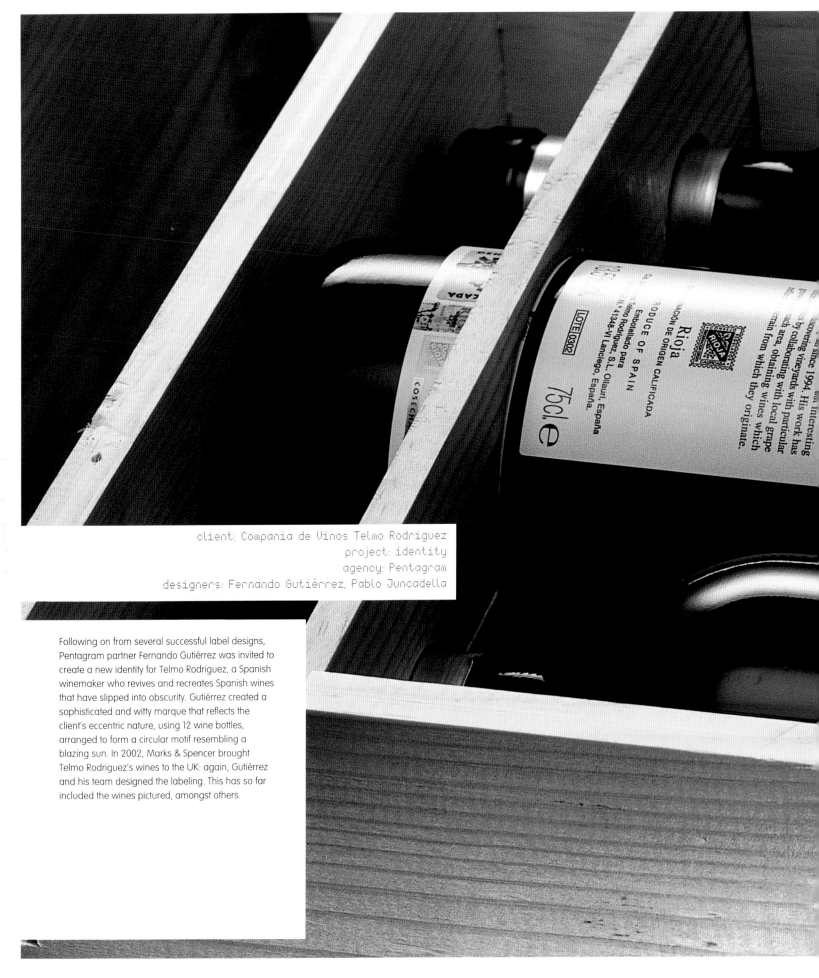

client: Compania de Vinos Telmo Rodriguez
project: identity
agency: Pentagram
designers: Fernando Gutiérrez, Pablo Juncadella

Following on from several successful label designs, Pentagram partner Fernando Gutiérrez was invited to create a new identity for Telmo Rodriguez, a Spanish winemaker who revives and recreates Spanish wines that have slipped into obscurity. Gutiérrez created a sophisticated and witty marque that reflects the client's eccentric nature, using 12 wine bottles, arranged to form a circular motif resembling a blazing sun. In 2002, Marks & Spencer brought Telmo Rodriguez's wines to the UK: again, Gutiérrez and his team designed the labeling. This has so far included the wines pictured, amongst others.

client: Jan and Tomas Pettersen
project: Fernando de Castilla brandy rebrand and sherry launch
agency: Design Bridge
designers: Graham Shearsby, Antonia Hayward

When Jan and Tomas Pettersen acquired Fernando de Castilla, a Spanish brandy, in 2000, Design Bridge was challenged to take from the brand traditional category cues and create a contemporary brand marque that could be used on- or off-pack. The designers achieved this via the "F de C" diamond and an unusual gray and orange color palette, not normally associated with brandies. Design Bridge was also invited to design the packaging for a new Fernando de Castilla range of ultra-premium, small-batch, very high-quality sherries. The idea was to reflect the character of the sherry through a distinctive letterform on the label. The letterforms are printed on high-quality paper with embossed lettering and a slight shadow effect.

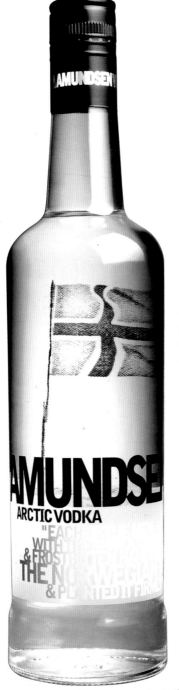

client: Arcus
project: Amundsen vodka launch
agency: Design Bridge
designer: Graham Shearsby

This Norwegian vodka was inspired by Norway's polar explorer Amundsen, giving the product a good sense of provenance, adventure, and national pride. Arcus had actually copyrighted the name "Admundsen" decades ago, but only recently got around to exploiting its potential. Design Bridge came up with a very contemporary, stylish design, with bold, confident graphics. The Norwegian flag—symbol of Amundsen's achievements—is screen-printed on the back of the bottle, while the copy tells the story of the moment when the explorer and his team planted their flag at the South Pole, beating Scott.

"It's very bold and simple, and aimed at a younger market," says Design Bridge creative director Graham Shearsby. "We avoided doing something too nostalgic, because the company wanted this to look good in a contemporary Norwegian style bar."

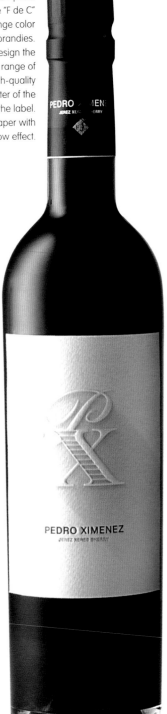

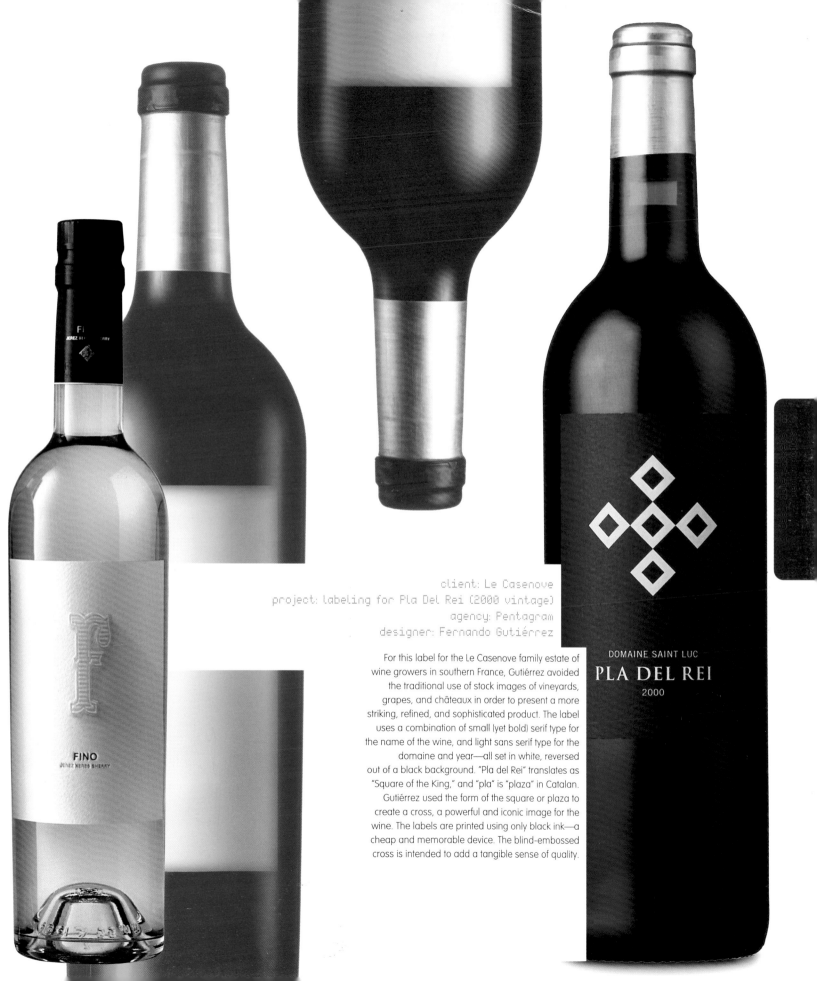

client: Le Casenove
project: labeling for Pla Del Rei (2000 vintage)
agency: Pentagram
designer: Fernando Gutiérrez

For this label for the Le Casenove family estate of
wine growers in southern France, Gutiérrez avoided
the traditional use of stock images of vineyards,
grapes, and châteaux in order to present a more
striking, refined, and sophisticated product. The label
uses a combination of small (yet bold) serif type for
the name of the wine, and light sans serif type for the
domaine and year—all set in white, reversed
out of a black background. "Pla del Rei" translates as
"Square of the King," and "pla" is "plaza" in Catalan.
Gutiérrez used the form of the square or plaza to
create a cross, a powerful and iconic image for the
wine. The labels are printed using only black ink—a
cheap and memorable device. The blind-embossed
cross is intended to add a tangible sense of quality.

FINO
JEREZ XERES SHERRY

DOMAINE SAINT LUC
PLA DEL REI
2000

client: Bombay Brasserie
project: Bombay Brasserie takeaway
meals range for Sainsbury's
agency: Parker Williams
photographer: Gus Filgate

The Bombay Brasserie—one of the world's most acclaimed Indian restaurants—drafted in Parker Williams to design the packaging for a new range of 14 products, exclusive to UK supermarket giant Sainsbury's. The Bombay Brasserie and Noon Products created an authentic Indian restaurant-style menu that embraces a variety of different regions and cooking techniques. Building on the equities of the original Bombay Brasserie meal for two, the new design displays authentic Indian cues steeped in tradition, with a contemporary twist. The premium positioning of the range is communicated through the black and gold oval of the Bombay Brasserie branding device. Evocative, rich food photography (by D&AD award-winning Gus Filgate) reflects the quality and tastiness of the food, while the deep red background is intended to display the intensity of the flavors.

When Matthew Algie decided to rationalize its range of teas into one consolidated brand, Golden Tip, it took on Glasgow-based Graven Images. Golden Tip was the best-known of the existing tea products in its range, and the distinctive black, red, and gold color combination was to be retained. Two designs were required—Golden Tip and Golden Tip Earl Grey; both incorporate the new Matthew Algie identity, also designed by Graven. "We decided to go back to the inspiration for the original packaging design, which was oriental decorative ceramics and lacquered boxes," says Mandy Nolan, head of graphics. "We wanted to create a distinctive graphic pattern inspired by cherry, plum, and pomegranate blossom. The graphic had to work on extremes of scale—from the tag that attaches to the teabag to packing cartons and point-of-sale."

client: Matthew Algie
project: Golden Tip Tea
agency: Graven Images
designer: Graven Images design team

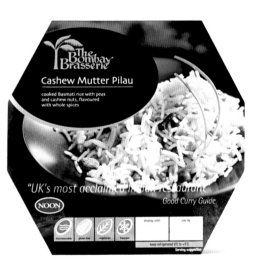

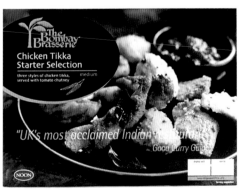

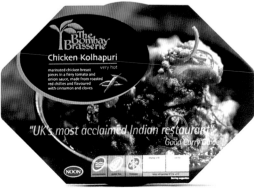

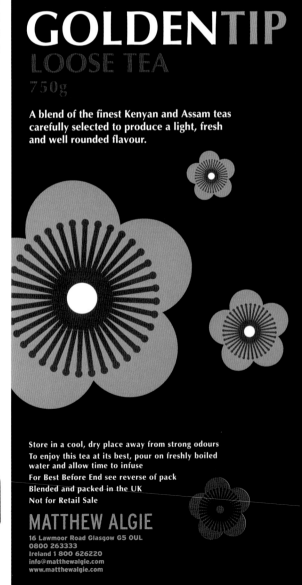

client: Grand Hyatt Hotel, Dubai
project: Panini Italian bakery packaging
agency: Lewis Moberly
designer: Hideo Akiba
illustrator: Fiona Verdon-Smith

Panini was one of a number of packaging designs and restaurant identities completed by Lewis Moberly for the new Grand Hyatt in Dubai. All these projects were part of the same complex, but the aim was to make each one completely distinct, as though run by an individual proprietor. "We had to really think about what each restaurant was offering, and its culture," explains Nicola Cooper, project director. "Panini is an Italian bakery, so it was much more about serving coffees and take-aways than eating in. It was more relaxed."

"The illustration style reflects the spontaneous, casual, exciting Italian," adds Mary Lewis, creative director. "It makes me smile: it's joyful. A lot of our identities were quite minimal for this project—because the hotel is anything but minimal, it's very Arabic-opulent. To have any kind of impact, simplicity was the key."

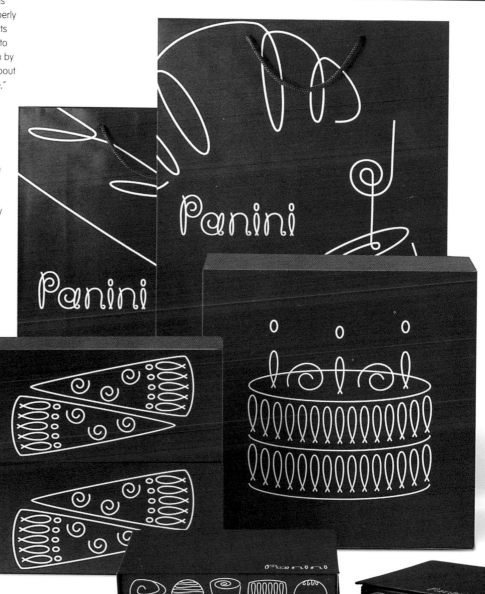

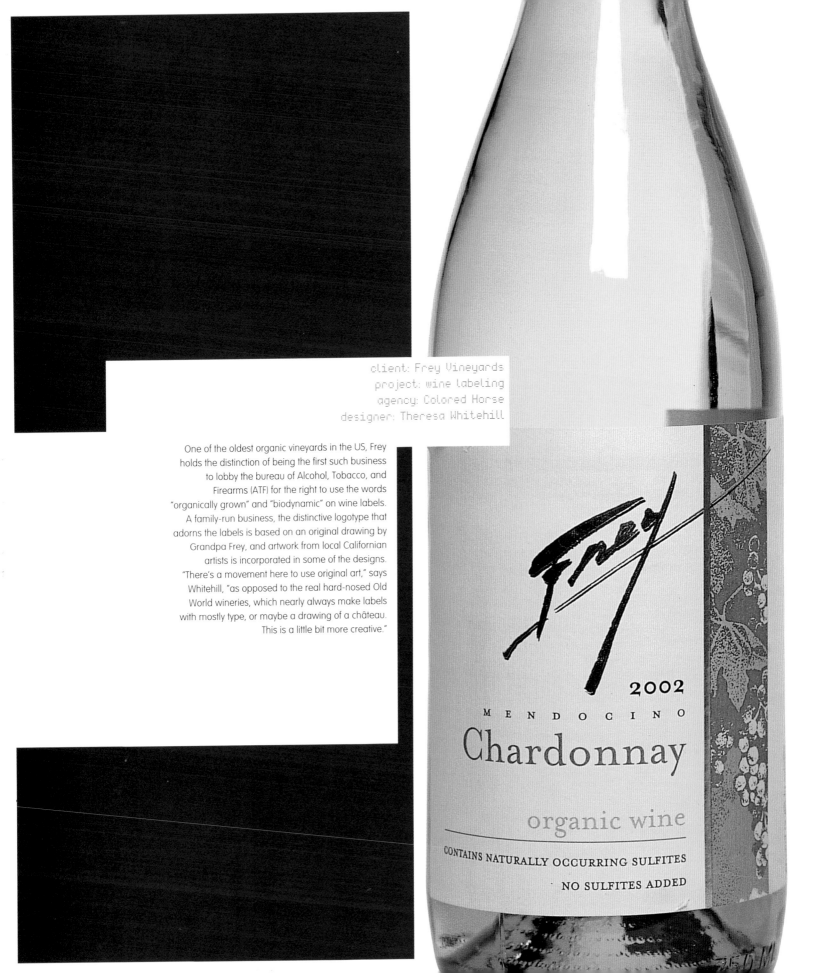

client: Frey Vineyards
project: wine labeling
agency: Colored Horse
designer: Theresa Whitehill

One of the oldest organic vineyards in the US, Frey holds the distinction of being the first such business to lobby the bureau of Alcohol, Tobacco, and Firearms (ATF) for the right to use the words "organically grown" and "biodynamic" on wine labels. A family-run business, the distinctive logotype that adorns the labels is based on an original drawing by Grandpa Frey, and artwork from local Californian artists is incorporated in some of the designs. "There's a movement here to use original art," says Whitehill, "as opposed to the real hard-nosed Old World wineries, which nearly always make labels with mostly type, or maybe a drawing of a château. This is a little bit more creative."

Frey

2002

M E N D O C I N O

Chardonnay

organic wine

CONTAINS NATURALLY OCCURRING SULFITES

NO SULFITES ADDED

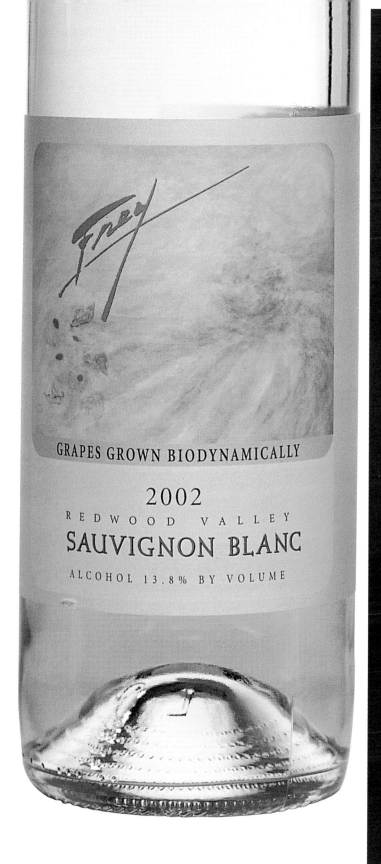

GRAPES GROWN BIODYNAMICALLY

2002

R E D W O O D V A L L E Y
SAUVIGNON BLANC

ALCOHOL 13.8% BY VOLUME

2002

REDWOOD VALLEY

Merlot

organic wine

CONTAINS NO DETECTABLE SULFITES

NO SULFITES ADDED

global
domination

big brands and design classics

client: Lipton
project: Lipton Specialty Teas
date: 2002
agency: Lipson Alport Glass
& Associates
designer: Rob Swan

The core objectives of this redesign of the Lipton Specialty Teas range were to fold the products into a strong masterbrand architecture, create unique and proprietary graphic personalities for each product, reinforce the brand's new confident and contemporary positioning, and reach a younger demographic.

A combination of several illustration techniques (digital composition with painting, for instance) was used to create the desired impression. Emphasis was placed on a strategic approach that would provide a complete brand promise. The resulting designs presented new promotional opportunities, such as creating complementary tea cups.

The new packaging has helped fuel growth in this expanding category. In addition to achieving significant consumer shelf impact, Lipson Alport Glass & Associates' work for Lipton Teas received numerous awards. The Lipton Tea Line received a finalist award from the 17th annual London International Advertising Award, the Green Teas received American Graphic Design and American Corporate Identity 19 awards, while the Herbal Teas received a Finalist Certificate from the New York Festival's Print Advertising competition and American Corporate Identity 19 awards.

client: The Pillsbury Company
project: Häagen-Dazs Gelato
date: 2000
agency: FutureBrand
designer: Laura Fang

The Pillsbury Company took on FutureBrand to help it launch a new Häagen-Dazs sub-brand, Gelato. While the name Gelato was not in itself felt to be especially ownable, designer Fang created a handwritten logo that captured the concept of old-world, intense flavors, reflecting the product's proposition. Tower of Pisa graphics and a copy line in Italian reinforce Gelato's heritage, and provide a meaningful visual device for the brand to use in applications beyond packaging. The graphics, meanwhile, convey the client's message of premium quality, distinctiveness, and taste indulgence.

client: The Pillsbury Company
product: Häagen-Dazs
date: 1999
agency: FutureBrand
designer: Laura Fang

Häagen-Dazs, a leader in premium ice cream, was facing increasing competition in global markets. The product is obviously highly regarded, but its packaging was thought to be a hindrance to achieving the company's aggressive sales growth targets. Using worldwide consumer research in Europe, Japan, and the US, FutureBrand developed a design that captures the smooth, rich quality associated with the product, while keeping just enough traditional visuals so that loyal customers would easily find their favorite brand. The winning design was implemented across all product segments and includes single and multipack solutions for tubs, stick bars, and individual servings. It was then rolled out to signage and collateral in 54 countries.

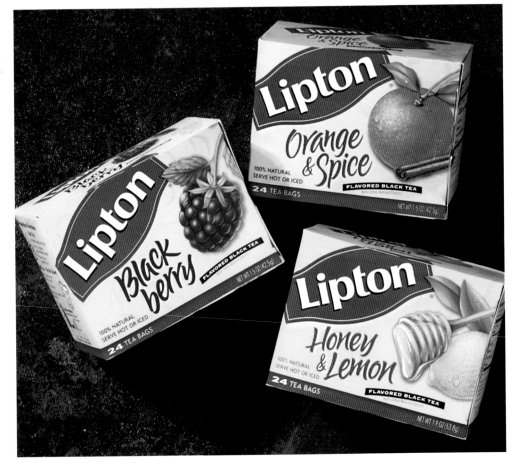

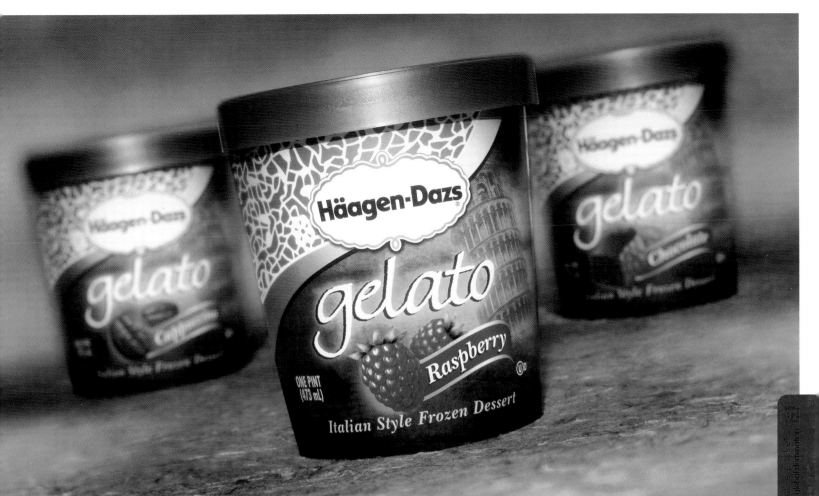
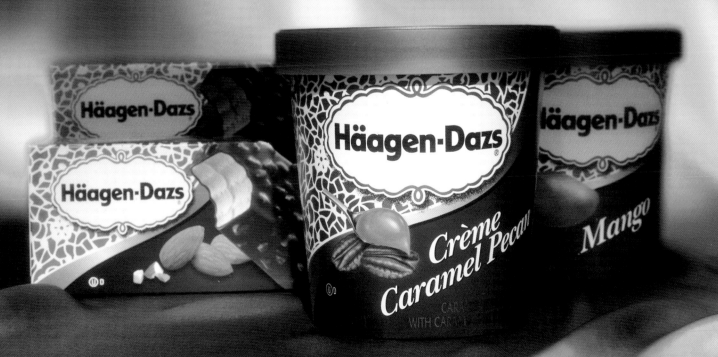

Dream Whip® BRAND

WHIPPED TOPPING MIX

Dream Pie RECIPE ON BACK

SERVING SUGGESTION

Ⓚ D

EACH ENVELOPE MAKES 2 CUPS
TWO ENVELOPES

NET WT 2.6 OZ (73g)

DIRECTIONS

• 1 envelope DREAM WHIP Whipped Topping Mix
• 1/2 cup cold milk*
• 1/2 tsp. vanilla

MIX whipped topping mix, milk and vanilla in large bowl with electric mixer on low speed until blended.

BEAT on high speed for 4 minutes or until topping thickens and forms peaks.

Use immediately, covered until ready to use.

...y (prepared and ...weight), lactose-reduced ...also can be used.

...chen is hot (over 85°F), ...e bowl and beaters before ...ingredients. Do not refrigerate ...WHIP package.

Dream Whip®
WHIPPED TOPPING MIX BRAND
DREAM PIE RECIPE ON SIDE
SERVING SUGGESTION
TWO 1.3 OZ (36g) ENVELOPES
NET WT 2.6 OZ (73g)
EACH ENVELOPE MAKES 2 CUPS
KD

client: Kraft Foods
project: Dream Whip
date: 2002
agency: Lipson Alport Glass
& Associates
designers: Rob Swan, Mark Krukonis

Revitalizing an aging product (original design inset) to make it more relevant to contemporary consumers, the new packaging is a complete redesign that maintains the core equities of the brand. A dynamic and proprietary logotype brings a more contemporary flair to the identity, while the photography has been enhanced and restaged to maximize appetite appeal.

client: The Kellogg Company
project: Cracklin' Oat Bran
date: 2003
agency: Source Design
designers: Mike Nicholson,
Scott Burns

In the US, Cracklin' Oat Bran is a well-established adult cereal that, according to Source Design vice president Michael Coleman, was saddled with a "sterile and uninviting look, a name that emphasized its 'so-healthy-it-couldn't-possibly-taste-good' heritage, and food imagery that failed to overcome the challenges of the product's appearance."

Designer Nicholson adds: "This is a product whose time has come. As consumers begin to understand that food health profiles should be measured on a range of metrics—not just one or two ingredients—and increasingly look for a small reward in their stressful lives, Cracklin' Oat Bran stands squarely at the intersection of these cultural trends."

The new design reinvents Cracklin' Oat Bran's packaging, investing it with a more indulgent, treat-like sensibility through significantly improved food imagery. The hierarchy in the name has been managed to emphasize "Cracklin" over "Bran", while the brand is contained and staged in a banner surrounded by a burst of rich gold rays.

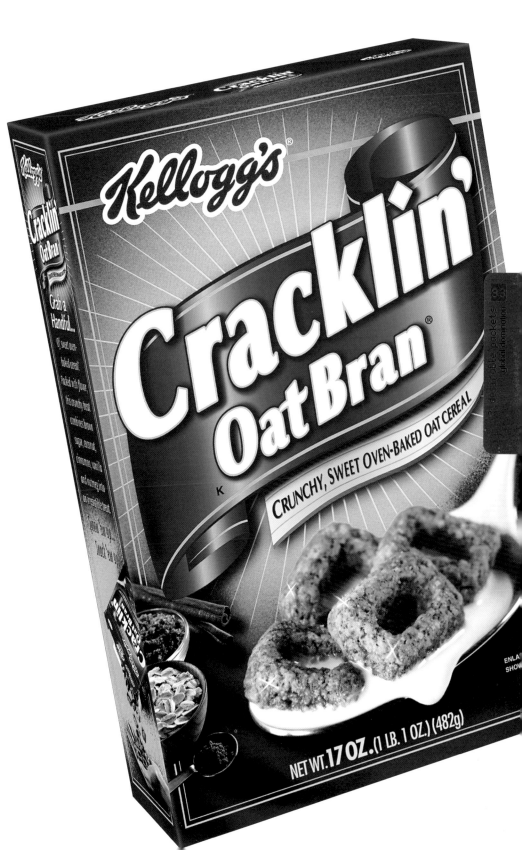

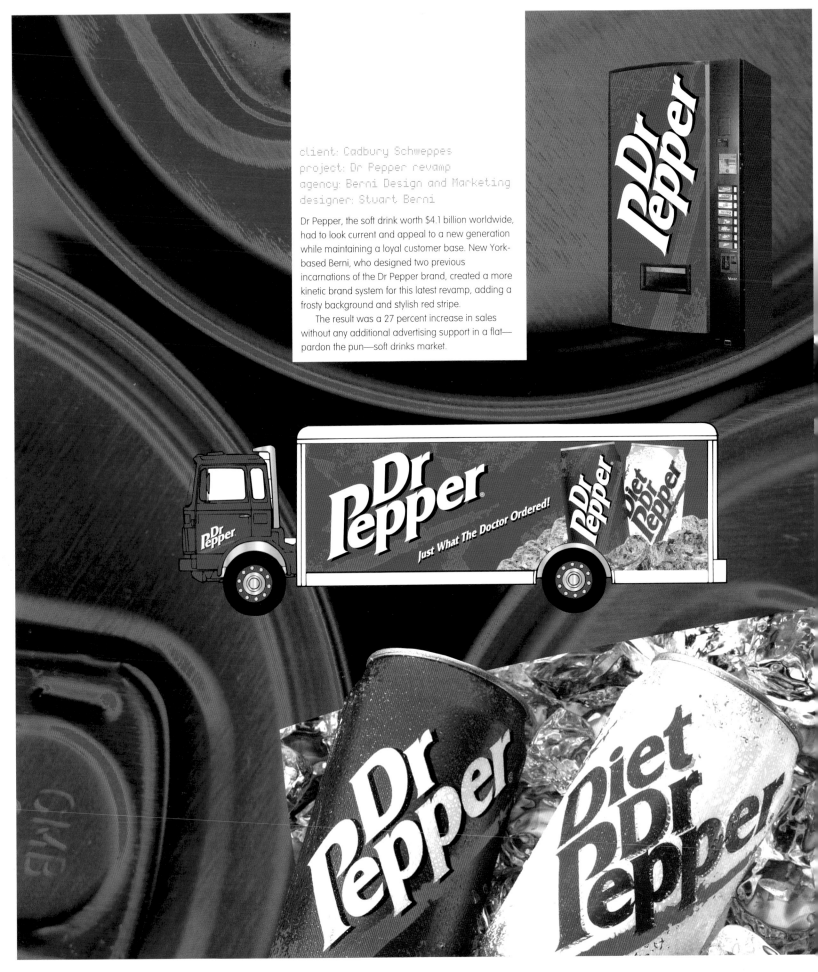

client: Cadbury Schweppes
project: Dr Pepper revamp
agency: Berni Design and Marketing
designer: Stuart Berni

Dr Pepper, the soft drink worth $4.1 billion worldwide, had to look current and appeal to a new generation while maintaining a loyal customer base. New York-based Berni, who designed two previous incarnations of the Dr Pepper brand, created a more kinetic brand system for this latest revamp, adding a frosty background and stylish red stripe.

The result was a 27 percent increase in sales without any additional advertising support in a flat—pardon the pun—soft drinks market.

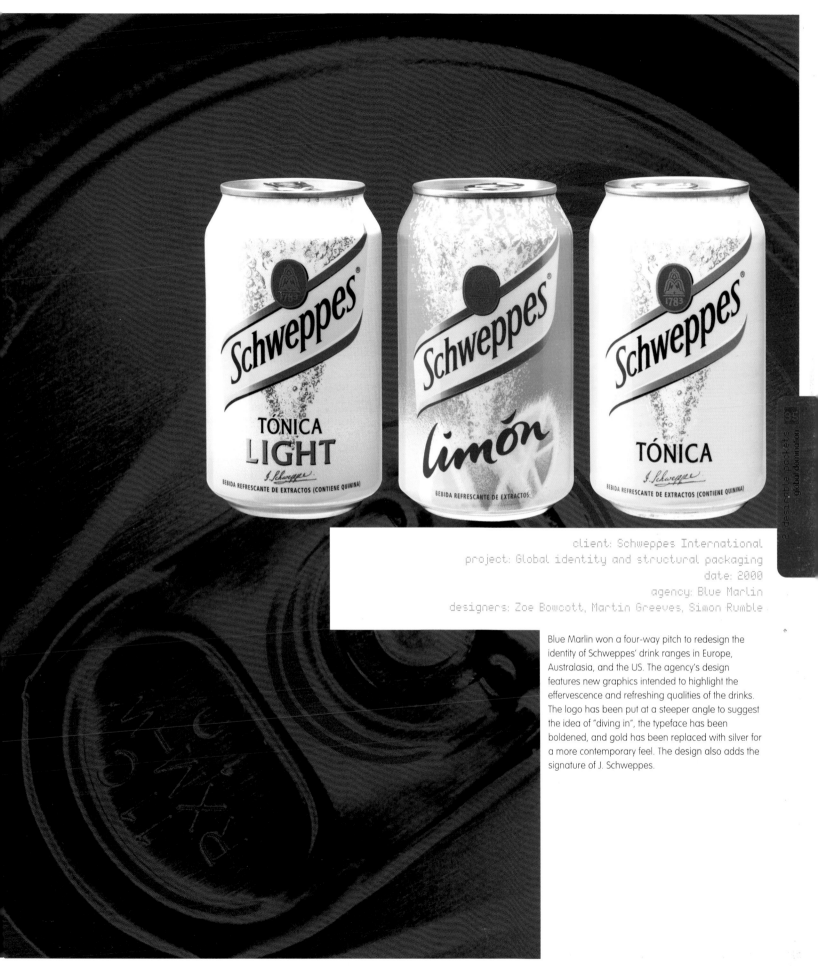

client: Schweppes International
project: Global identity and structural packaging
date: 2000
agency: Blue Marlin
designers: Zoe Bowcott, Martin Greeves, Simon Rumble

Blue Marlin won a four-way pitch to redesign the identity of Schweppes' drink ranges in Europe, Australasia, and the US. The agency's design features new graphics intended to highlight the effervescence and refreshing qualities of the drinks. The logo has been put at a steeper angle to suggest the idea of "diving in", the typeface has been boldened, and gold has been replaced with silver for a more contemporary feel. The design also adds the signature of J. Schweppes.

Since the first outlet opened in London in 1996, the EAT brand has grown considerably, with 25 cafes now in the city. Pentagram partner Angus Hyland was appointed to evolve the existing identity and to redefine the EAT brand. A core proposition was developed to guide all ongoing work. The proposition highlighted the honesty at the heart of EAT's business—a business that is owned by real people (rather than a corporation) who have a genuine passion for food and drink. Communication of the proposition was achieved by developing a new logotype and design language. A new strapline— "The Real Food Company"—was also developed to further suggest the brand's values.

Hyland and his team developed all areas of the new brand identity. The new logotype employs a bold sans serif typeface (Akzidenz Grotesk), to communicate the warmth and quality of the brand with a distinct, contemporary tone. The typographical language has been combined with a color palette of warm, natural, brown hues, with a range of more vibrant minor colors for typography and detailing across food packaging and other collateral.

client: EAT
project: EAT identity
date: 2002
agency: Pentagram
designer: Angus Hyland

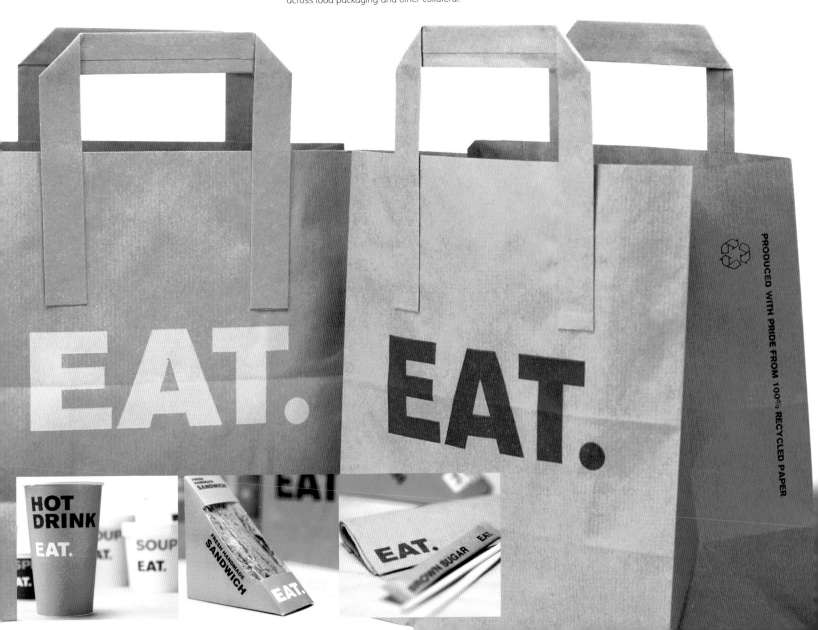

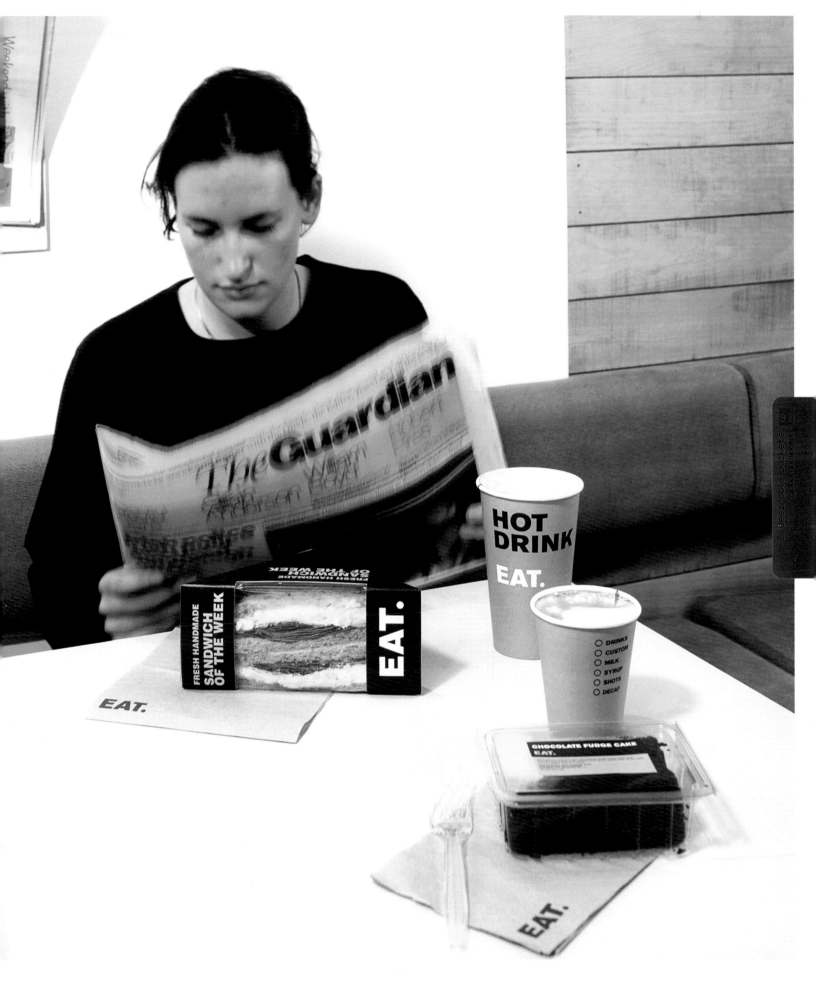

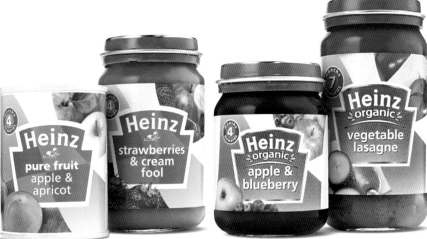

client: Heinz
project: Heinz Babyfood
date: 2001
agency: Jones Knowles Ritchie
designers: Jones Knowles Ritchie
design team

Heinz Babyfood is the leading brand in the "wet" sector of the category, but due to the rapid growth of organic ranges, market share was being lost to competitor brands.

Jones Knowles Ritchie's brief was to redesign the Heinz Babyfood range, making it more "contemporary and relevant" by focusing on "real food". The first objective was to apply the Heinz keystone to Babyfood, as this was only remaining range that didn't feature Heinz's core branding. This allowed the range to draw on the trust and reassurance associated with the parent brand, and dispel the "men in white coats" feel of the previous design.

The pack was divided into dynamic quadrants that allow a dynamic representation of the key foodstuffs within each product. The standard cans and jars were given an overall range color of green to echo organic values. The orange organic range, meanwhile, breaks market color codes, to stand out from other organic (predominantly green) brands.

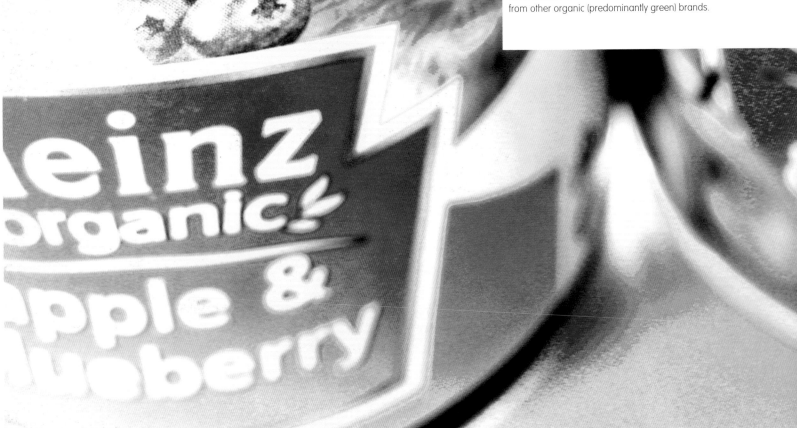

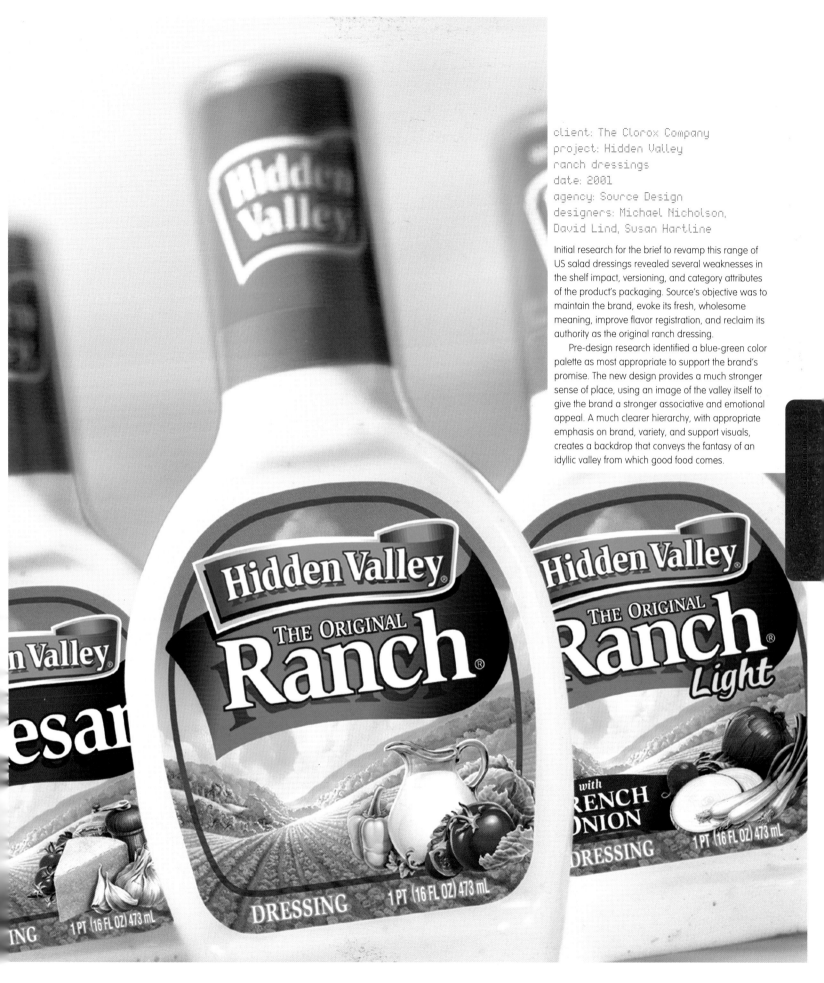

client: The Clorox Company
project: Hidden Valley
ranch dressings
date: 2001
agency: Source Design
designers: Michael Nicholson,
David Lind, Susan Hartline

Initial research for the brief to revamp this range of US salad dressings revealed several weaknesses in the shelf impact, versioning, and category attributes of the product's packaging. Source's objective was to maintain the brand, evoke its fresh, wholesome meaning, improve flavor registration, and reclaim its authority as the original ranch dressing.

Pre-design research identified a blue-green color palette as most appropriate to support the brand's promise. The new design provides a much stronger sense of place, using an image of the valley itself to give the brand a stronger associative and emotional appeal. A much clearer hierarchy, with appropriate emphasis on brand, variety, and support visuals, creates a backdrop that conveys the fantasy of an idyllic valley from which good food comes.

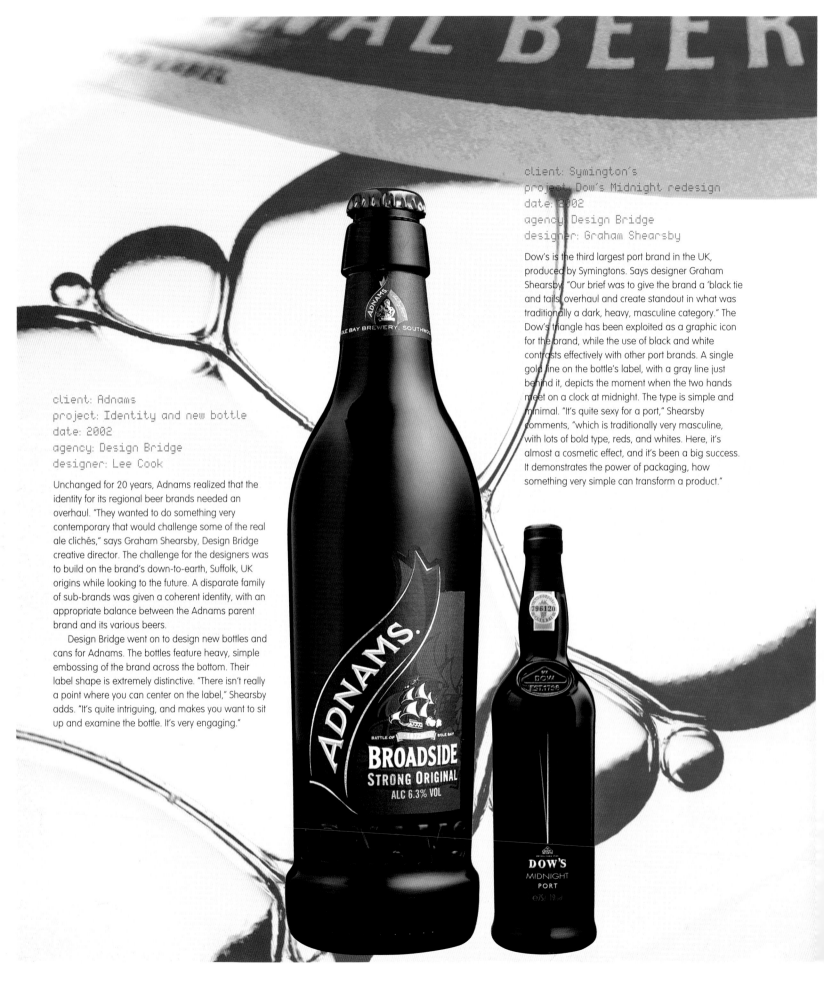

client: Adnams
project: Identity and new bottle
date: 2002
agency: Design Bridge
designer: Lee Cook

Unchanged for 20 years, Adnams realized that the identity for its regional beer brands needed an overhaul. "They wanted to do something very contemporary that would challenge some of the real ale clichés," says Graham Shearsby, Design Bridge creative director. The challenge for the designers was to build on the brand's down-to-earth, Suffolk, UK origins while looking to the future. A disparate family of sub-brands was given a coherent identity, with an appropriate balance between the Adnams parent brand and its various beers.

Design Bridge went on to design new bottles and cans for Adnams. The bottles feature heavy, simple embossing of the brand across the bottom. Their label shape is extremely distinctive. "There isn't really a point where you can center on the label," Shearsby adds. "It's quite intriguing, and makes you want to sit up and examine the bottle. It's very engaging."

client: Symington's
project: Dow's Midnight redesign
date: 2002
agency: Design Bridge
designer: Graham Shearsby

Dow's is the third largest port brand in the UK, produced by Symingtons. Says designer Graham Shearsby, "Our brief was to give the brand a 'black tie and tails' overhaul and create standout in what was traditionally a dark, heavy, masculine category." The Dow's triangle has been exploited as a graphic icon for the brand, while the use of black and white contrasts effectively with other port brands. A single gold line on the bottle's label, with a gray line just behind it, depicts the moment when the two hands meet on a clock at midnight. The type is simple and minimal. "It's quite sexy for a port," Shearsby comments, "which is traditionally very masculine, with lots of bold type, reds, and whites. Here, it's almost a cosmetic effect, and it's been a big success. It demonstrates the power of packaging, how something very simple can transform a product."

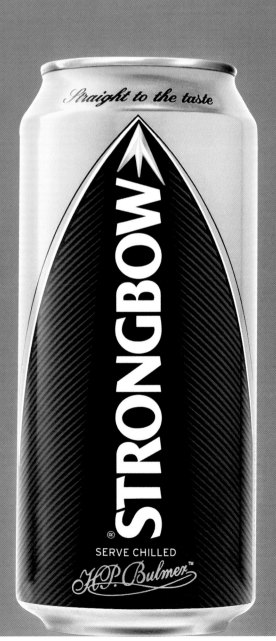
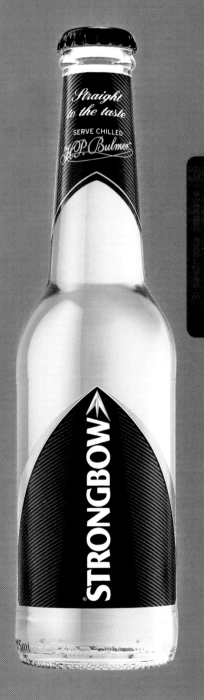

client: HP Bulmer
project: Strongbow relaunch
date: 2002
agency: Coley Porter Bell
designers: Martin Grimer,
Stewart Humm

Historically, cider has suffered from something of an image problem, meaning that design agency Coley Porter Bell had an interesting challenge on its hands when awarded the brief to redesign the packaging for Strongbow. "It was a difficult one," says creative director Martin Grimer. "It's a first entry drink, a last exit drink, and it has some negative connotations—either of teenagers getting wasted or of guys sleeping on park benches."

The brief was to give Strongbow's packaging more quality cues and to reflect the product's immediacy and refreshing taste. Strongbow's previous packaging, says Grimer, was: "Blunt and bold, doing nothing to reflect those quality credentials." The designers decided to remove those elements of the old pack that weren't relevant any more—including one of the icons of the brand, its archer (Grimer: "He was ready to shoot his arrows and looked like he might blow your brains out—the kind of cider association that we were trying to get away from!"). The designers kept the arrow itself, however, running it vertically up the bottle with the logo.

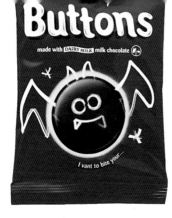
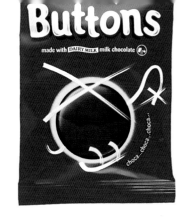
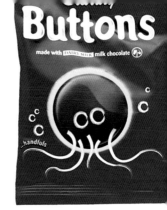

client: Cadbury's
project: Buttons relaunch
date: 2002
agency: Coley Porter Bell
designers: Martin Grimer, Adam Ellis

The task was to redesign Cadbury's chocolate Buttons for an audience beyond the children's market. When looking for an idea for the new packaging, they began by thinking about activities that people do as children and adults. Eventually, they settled on doodling. "From the classroom to the boardroom, people make doodles," says Martin Grimer, creative director.

The designers decided to use the chocolate button itself as the brand icon, centrally displayed as the hero of the pack, and placed doodles on top of it to "add personality." Punning copy lines and jokes on the back of the packs ensure that the language of the packaging adds to the brand character. The color purple was chosen for the packaging, as it is synonymous with Cadbury's.

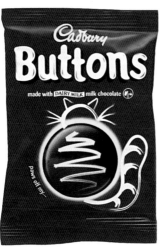
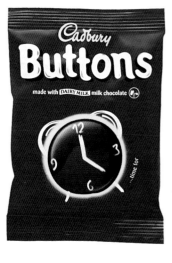
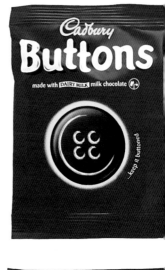

client: McVitie's
project: McV launch
date: 2002
agency: Design Bridge
designer: Lee Cook

"The brief here was very straightforward," says Design Bridge's Graham Shearsby: "24-7 irresistibility." McVitie's the brand—similar to some of the agency's other recent projects—needed modernizing to move into younger markets. "The view was that their products should be a whole experience," Shearsby adds. "They wanted to make their biscuits more snacky, more crisp-like." The packaging was simplified and the angle of the logo changed, but the most radical overhaul concerned the name of the brand itself: from McVitie's to McV. As it turns out, this abbreviation had its roots in Design Bridge's own internal communications. "We'd been working with the brand for a number of years and we would always call the client McV, or McVits," Shearsby explains. "It was the obvious choice when we were asked to make things more snappy."

"It was an extremely bold move," he adds, "but it's been very successful for them. It's moved them out of Auntie's biscuit barrel and into that younger world where they wanted to be."

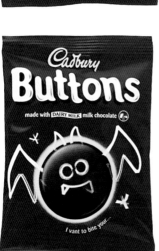
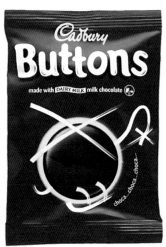
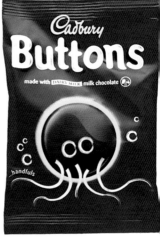

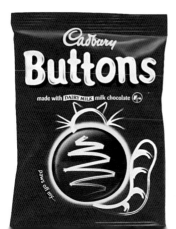
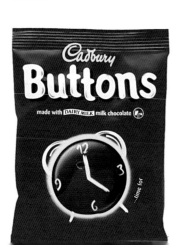
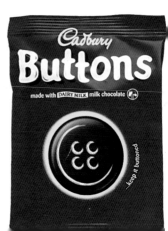

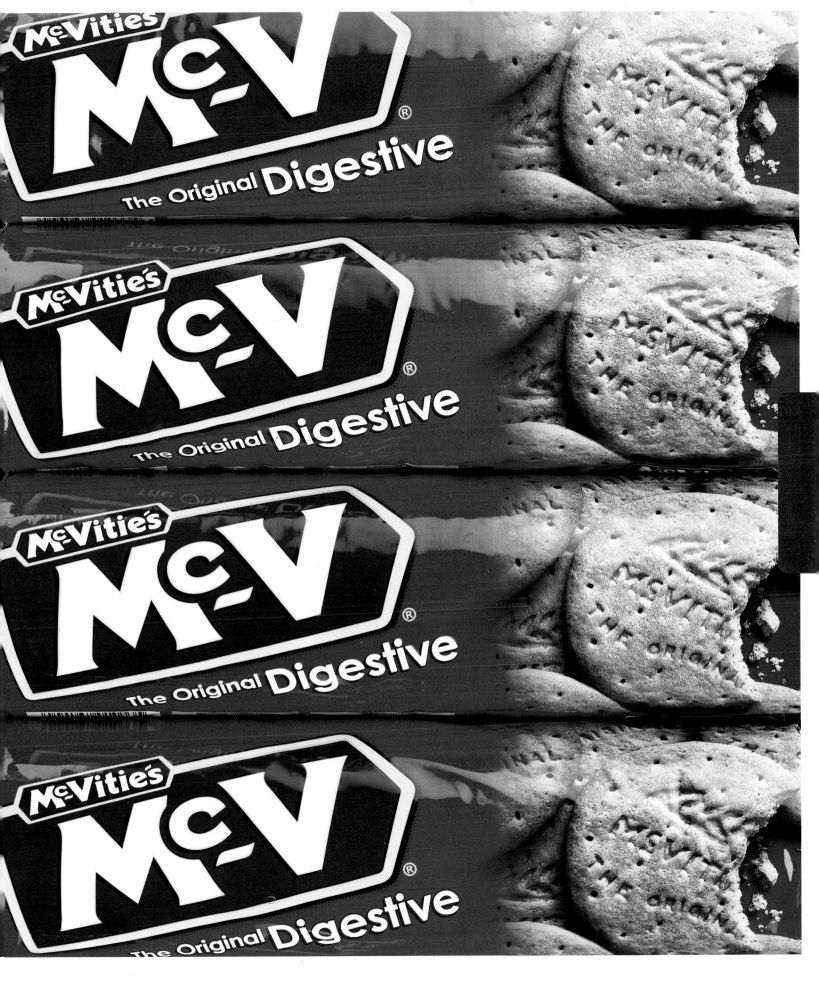

client: Virgin
product: Virgin Sours
date: 2003
agency: Bluedoor
designers: Jill Peel and team

Having already made forays into the drinks market with its cola product, UK mega-brand Virgin tasked Bluedoor with creating the packaging for Virgin Sours, a new range of soft drinks aimed at 8–14 year olds. Bluedoor's design features psychedelic packaging and has been backed up by similarly vibrant promotional campaigns at trade and consumer level. Initial consumer activity included advertising in traditional British children's comics.

The campaign as a whole is spearheaded by the agency's tagline, "So sour… So dare you?" Bluedoor account director David Worthington says: "This is the first drink of its kind, so in line with Virgin brand values we've dared to be different. The introduction of sours rocked the confectionery world last year and we're confident the same is about to happen with soft drinks."

"Virgin is a very exciting brand that demands a unique approach," says Sarah Hemming, brand manager for Virgin. "With such a high-profile product launch, the creative had to be out of the ordinary and a bit off the wall."

client: Diageo
project: Gordon's Gin redesign
date: 2002
agency: Design Bridge
designers: Graham Shearsby,
Neil Hurst

Long seen as the favorite tipple of middle-aged drinkers, gin has struggled in recent years to maintain market share against other, more fashionable spirits such as vodka. Market-leading Gordon's, unchanged for 60 years and with an iconic presentation, needed to change. Bedevilled by "me-too" packaging from a legion of competitors, Design Bridge was drafted in to make improvements. "To sit comfortably in the new era of bar culture that we're in now, things needed to develop," says designer Graham Shearsby. "We kept the essence of the original pack, which was curved at the back, and just accentuated that to make this D-shaped pack that feels really comfortable in the hand." Design Bridge reduced the size of the label to increase the impact of light shining through the distinctive green bottle. The scripted lettering of the old pack—"almost like a wedding invitation"—was simplified so that the focus is on the word "Gordon's".

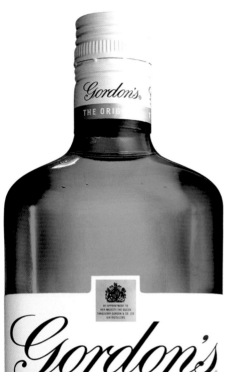

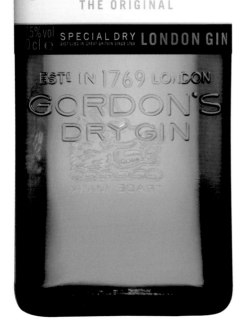

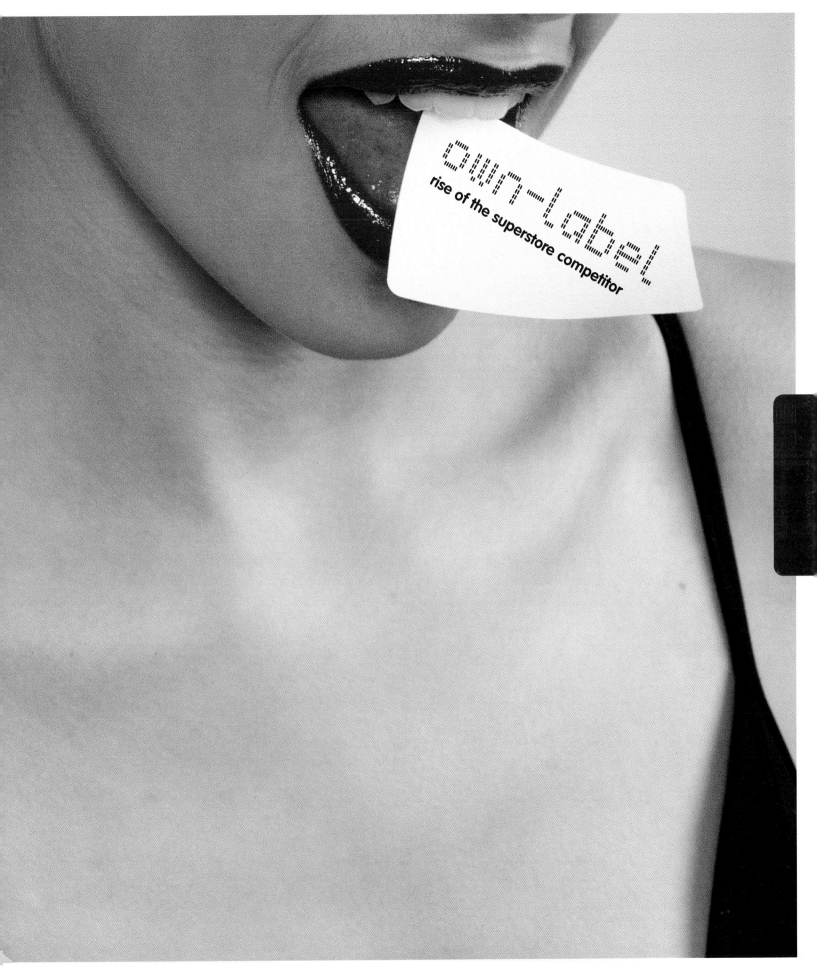

own-label
rise of the superstore competitor

In a recent rebranding of all its food products, Boots chose to reinvent its popular Shapers health food. Reflecting shifts in consumers' attitudes toward healthy eating, Boots wanted the new packaging to focus more on the healthy ingredients of its products rather than on dieting—previous packaging had prominently featured a tape measure. Roundel's brief was to replace this design with a subtler alternative.

"We took a message and information-led approach," says Roundel's Tanya Davies, "which makes it easy for customers to choose the right product. This is reflected in the honesty and clarity of the packaging; the design is stripped bare of any unnecessary information without detracting from its intended personality." Roundel's decision to ditch the tape measure also reflects the increasing cross-gender appeal of the range. Davies adds: "This helps to attract a wider customer base, both male and female, who may have previously been put off by the associations of the tape measure but enjoy eating healthily."

client: Boots
project: Shapers relaunch
agency: Roundel
designers: John Bateson, Tanya Davies

SHAPERS
Boots

salt and vinegar
crunchy sticks

95 calories 3.8g fat 0.3g saturated fat Meal Deal

SHAPERS *Boots*

still
raspberry and mango drink

5 calories Meal Deal

SHAPERS

sparkling
peach drink

5 calories · Meal Deal

Vegetarian · Meal Deal

SHAPERS *Boots*

egg mayonnaise & cress

creamy egg mayonnaise and cress on oatmeal bread

305 calories · 9.9g fat · 2.4g saturated fat

USE BY KEEP REFRIGERATED PRICE

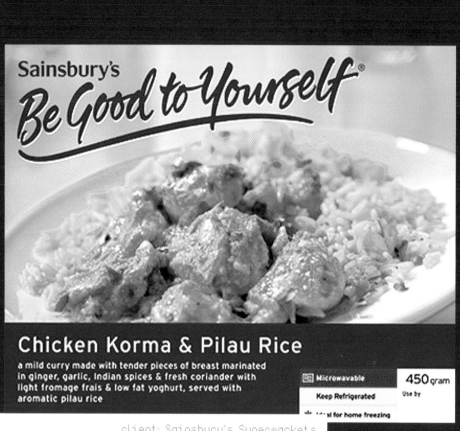

Sainsbury's

Be Good to Yourself®

Chicken Korma & Pilau Rice

a mild curry made with tender pieces of breast marinated in ginger, garlic, Indian spices & fresh coriander with light fromage frais & low fat yoghurt, served with aromatic pilau rice

Microwavable

Keep Refrigerated

450 gram

Use by

Ideal for home freezing

client: Sainsbury's Supermarkets
project: Be Good to Yourself redesign
agency: Parker Williams

Parker Williams was briefed to refresh and contemporize Sainsbury's Be Good to Yourself range in line with the new lifestyle positioning of the brand. The packaging also had to give the range strong shelf impact, while clearly communicating tighter nutritional criteria. The fronts of the redesigned Be Good to Yourself packs now show the fat, calorie, and saturated fat content using a clear labeling system, the colors of which relate directly to the new logo. In addition, there is now a band highlighting whether saturated fat, salt, sugar, or calories—whichever is most relevant to the product—has been controlled. The redesigned logo moves away from scripted lettering ("It actually looked too blobby, too high in fat, and too overprocessed," says creative director Tamara Williams) to a lower-case typeface. "It is leaner, cleaner, and more fresh—more now."

Sainsbury's
be good
to yourself
Serving suggestion
50% less fat
Keep refrigerated

mozzarella
low fat soft cheese with
a firm consistency

108 cal per ½ pack
6.3g fat per ½ pack
4.6 g saturated fat per ½ pack
suitable for vegetarians

Keep refrigerated
Do not freeze
Keep refrigerated
Do not freeze

Sainsbury's
be good
to yourself
Use by
Use by
less than 3% fat controlled calories

lemon mousse
with sugars and sweeteners
pots not to be sold separately

69 cal per pot
1.7g fat per pot
1.2g saturated fat per pot

Display until
Use by
Keep refrigerated
Do not freeze

250 gram ℮
(4 x 62.5 gram)
Use by
Keep refrigerated
Do not freeze

Sainsbury's
be good
to yourself

Serving suggestion

less than 3% fat controlled saturated fat & salt

skinless & boneless chunky
cod fillets in breadcrumbs

Frozen
Keep frozen
Storage instructions: see back of

Best before end

 180 cal per fillet
 3.5g fat per fillet
 0.2g saturated fat per fillet

Safeway in the UK decided to expand its range of own-label American products, so that it would become cross-category, appearing in different sections throughout the stores, and including items such as US cola and Tex-Mex sauces.

"It had to be easily recognizable for the consumer as being part of the American range, so it was about presenting what's essentially a cliché, but in a more sophisticated way," says creative director Jacqui Sinnatt. "One of our starting points—which you can see from the packaging—is that the food is very much upfront. We had to make sure the food sold itself, and make that the hero, and then find ways of creating this American-style message to support it."

client: Safeway
project: launch of own-label US range
agency: Butcher and Gundersen

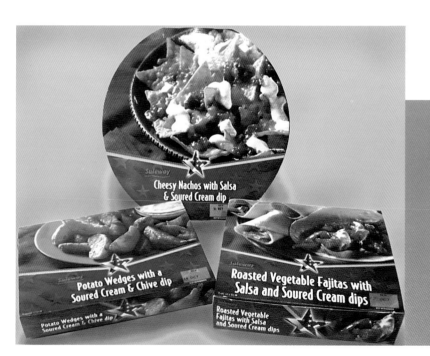

client: Sainsbury's Supermarkets
project: Blue Parrot Café relaunch
year: 2003
agency: Parker Williams

This redesign is the second iteration of Parker Williams' work on Sainsbury's Blue Parrot Café children's range. The original challenge was to create a kids' food brand that would make Sainsbury's the destination for kids' food. Parker Williams came up with the original Blue Parrot concept, which has proved a hit with consumers (it's interesting to note that a blue pelican was briefly touted—it was rejected as too fishy).

"Blue Parrot Café is seen as cool and aspirational," says creative director Tamara Williams, "and therefore it fits well with the target age group. It gives Sainsbury's a real point of difference, because it isn't just another 'me-too' cartoon character." She adds: "If you haven't got a licensed character to use that means something to people, just don't bother—it's not worth it. Also, there is a negative association with cartoons that is artificial, suggesting a lot of food additives."

The new design features an improved "traffic lights" labeling system for nutritional information (the previous design just had a tick box) and enhanced photography.

Sainsbury's blue Parrot café

alphabet crunch
honey coated maize, rice & oat alphabet shaped cereal

Fortified with Vitamins and Iron
✓ **A low fat food**

Sainsbury's policy of reducing additives is welcomed by the Hyperactive Children's Support Group.

Serving suggestion

Sainsbury's blue Parrot café

cottage pie with vegetables
minced beef topped with fresh mashed potato, served with carrots and peas

✓ Controlled salt
✓ Only natural flavours
✓ No added colours
✓ No preservatives
✓ No added flavour enhancers

Sainsbury's policy of reducing additives is welcomed by the Hyperactive Children's Support Group.

Keep Refrigerated
❋ Ideal for home freezing
300 gram
Display until Use by

client: Jelly Belly
project: Jelly Belly Holiday, Easter, and Valentine's Day gift packs
agency: Hornall Anderson Design Works
designers: Debra McCloskey, Steffanie Lorig, Beckon Wyld, Gretchen Cook, John Anderle

It's a sign of the times for food packaging that even jellybeans require a stylish approach to their packaging. In this case, the client felt its original holiday-related packaging design for the product wasn't sophisticated enough. Seattle-based agency Hornall Anderson designed a series of new holiday packaging encompassing Christmas, Valentine's Day, and Easter, with each showcasing a new family look depending on the holiday. On the gourmet line, metallic inks were used to differentiate the product from the standard line. "The redesign," says Hornall Anderson's Christina Arbini, "has given the Jelly Belly products higher quality, greater shelf presence, and launched them on to a gift-quality level."

client: Nordstrom
project: Nordstrom Chocolate Buttons candy
agency: Hornall Anderson Design Works
designers: Debra McCloskey, Steffanie Lorig, Beckon Wyld

Department store Nordstrom partnered Frans Chocolates to create this product, to be sold at its café counters. The chocolate is intended to be an impulse purchase, and the client wanted a design that would make the product easy to take away and consume on the move. Hornall Anderson's team designed a small metal container with a reusable lid for convenience and mobility, distinct from typical confectionery packaging. The design is intended to create a "fun, non-stuffy" look and feel.

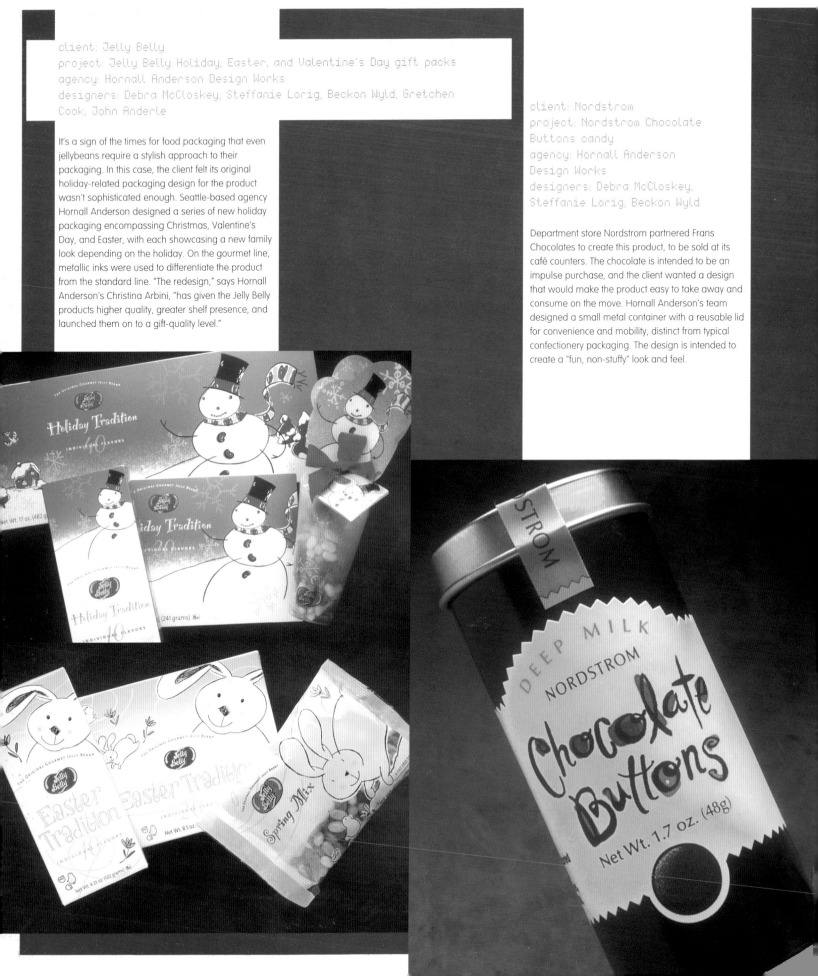

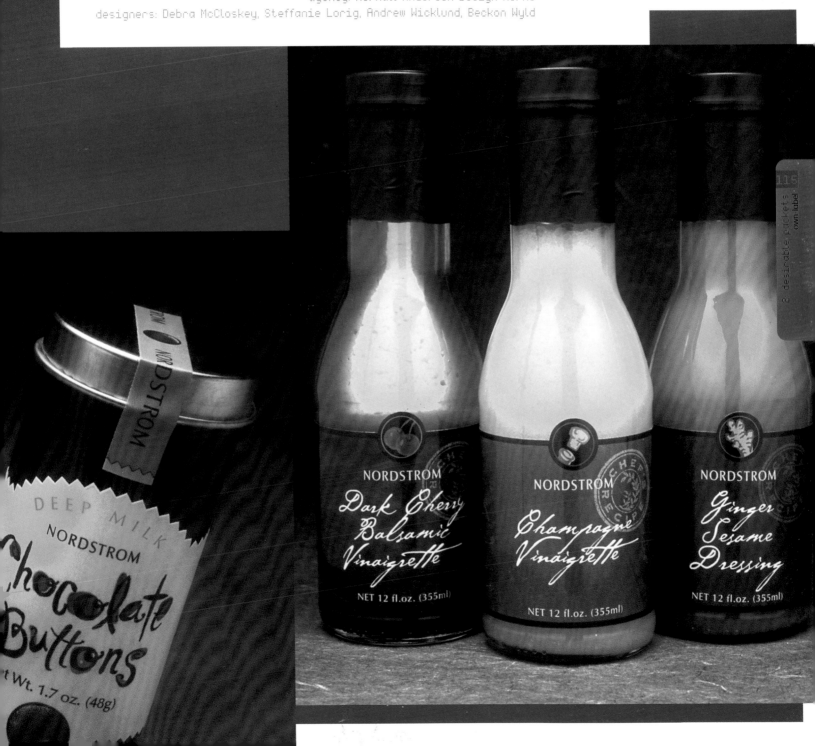

Looking for a takeaway product that would be sold in its cafés and bistros, high-end US department store Nordstrom approached Hornall Anderson to design the packaging for a range of gourmet salad dressings. Blending a hand-crafted font reflecting an Old World look and feel with descriptive illustrations and a rich color palette, the design team created a packaging family that was appropriate for both everyday use and gift-giving.

client: Nordstrom
project: Nordstrom salad dressings
agency: Hornall Anderson Design Works
designers: Debra McCloskey, Steffanie Lorig, Andrew Wicklund, Beckon Wyld

115

2 desirable packets
own label

client: Jack in the Box
project: Jack in the Box
date: 2002
agency: Hornall Anderson Design Works
designers: Jack Anderson, James Tee, Gretchen Cook, Elmer de la Cruz, Andrew Wicklund

After years of focusing its marketing efforts on a character, Jack in the Box wanted to upgrade the in-store and product experience for its range of sandwiches in the US. "Not only did we redesign the packaging for functionality," explains principal Jack Anderson, "but also as a vehicle to give the food higher visual appeal."

Distinct colors represent the different products, providing restaurant workers with quicker recognition for matching specific wraps with specific sandwiches. Hornall Anderson added to the equity of the Jack in the Box logo by developing a colorful, rich, ingredient-based illustrative style.

client: Rieber & Son
project: Mr Lee
date: 2002
agency: Design Bridge
designers: Ian Burren

Design Bridge created this look for a range of
noodles for the Norwegian market, basing its work
on the image of Korean founder Mr Choi Ho Lee.
The design is intended to mark out a distinct
personality for the brand—something playful and
engaging in the market—that takes its inventor as
the starting point but moves away to form a strong
image in its own right.

client: KAZI Beverage Company
project: KAZI
date: 2002
agency: Hornall Anderson Design Works
designers: Jack Anderson, Larry Anderson, Jay Hilburn, Kaye Farmer, Henry Yiu,
Bruce Stigler, Mary Chin Hutchinson, Sonya Max, Dorothee Soechting

Oregon-based KAZI recognized an opportunity to introduce something other than typical hard lemonade and tea drinks to the flavored alcoholic beverage market, creating a new position for this product which the company describes as a "cocktail in a glass".

"It was important that the product wasn't labelled as a lady's beverage," explains project manager Larry Anderson. "The KAZI packaging exudes honesty. A guy would feel comfortable taking it to a party, as opposed to a wine cooler."

The strategy behind the brand identity and graphics was to create a masculine and contemporary look, with a slightly edgy feel. The filtered photography treatment is intended to add to the product's classic, cool positioning—suggesting J. Crew meets Saturday Night Live. Introducing a touch of humor to the packaging, the inside of each bottle contains a pick-up line located on the reverse of the label, such as "I'm not the best-looking person here, but I'm the only one talking to you." In this case, the joke leans toward the 20-something male, KAZI's target market.

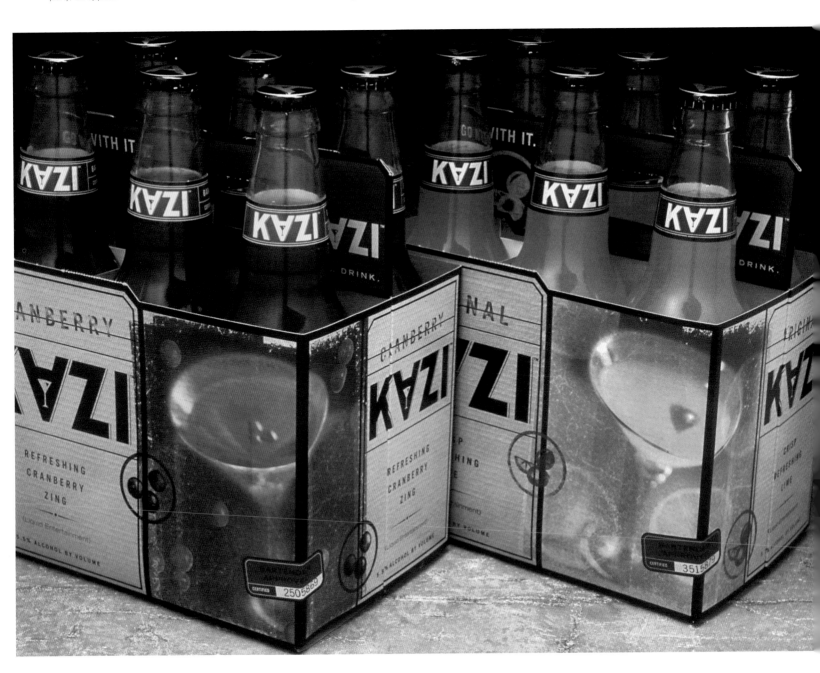

client: Widmer Brothers
project: Widmer Brothers Spring Run
date: 2003
agency: Hornall Anderson Design Works
designers: Jack Anderson, Larry Anderson, Jay Hilburn, Bruce Stigler,
Elmer de la Cruz, Dorothee Soechting

Widmer Brothers wanted to revive the packaging for its Spring Fest beer to give it greater standout. The designers renamed the product Spring Run, but kept a similar architecture and theme to the original packaging. The other big change was in terms of graphics, which the client felt were too soft. Bolder, more graphically active images relating to outdoor adventure replaced the original, subdued artwork.

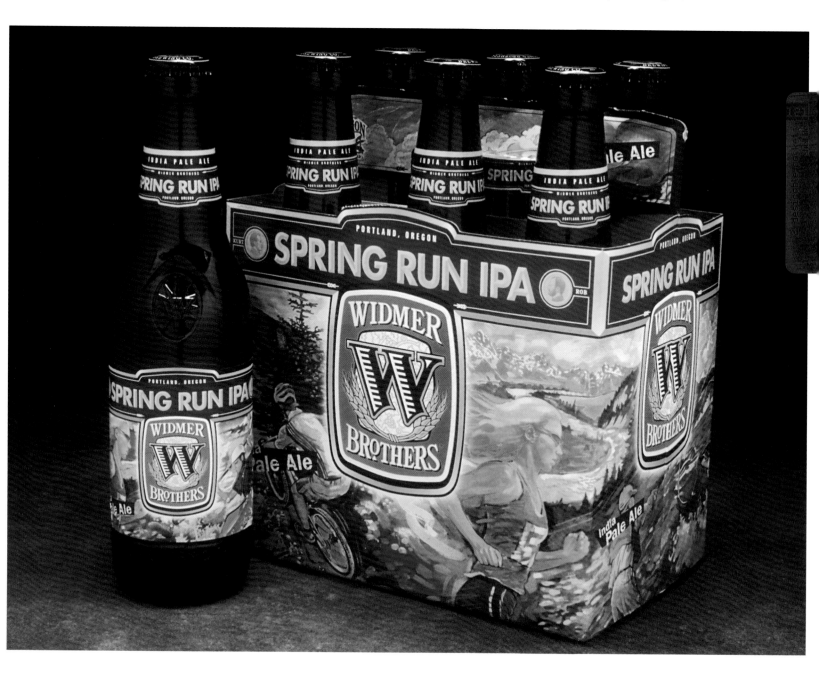

Widmer Brothers, an Oregon-based brewery and distributor, wanted to reposition one of its more popular pale ale brands. Originally named "Sweet Betty", this golden ale was struggling in the marketplace due to consumers mistakenly equating its name with a sweet-tasting beer.

Reintroducing the brand as "Blonde Ale", the design team created a fresher, more contemporary illustrative style that still had a place within the overall Widmer Brothers graphic architecture. The new Blonde Ale personality is a svelte, savvy woman, intended to appeal to a female and male audience in a more youthful demographic; Sweet Betty had been portrayed as a 1940-era woman.

The color palette ditches the old-fashioned sepia tone of the previous packaging to embrace a rich blue hue as a means of complementing the rest of Widmer Brothers range. It is also meant to suggest a hip, bold attitude that resonates with the 20–30 something target market.

client: Widmer Brothers
project: Widmer Brothers Blonde Ale
date: 2002
agency: Hornall Anderson Design Works
designers: Jack Anderson, Larry Anderson, Bruce Stigler, Henry Yiu, Jay Hilburn, Kaye Farmer, Don Stayner

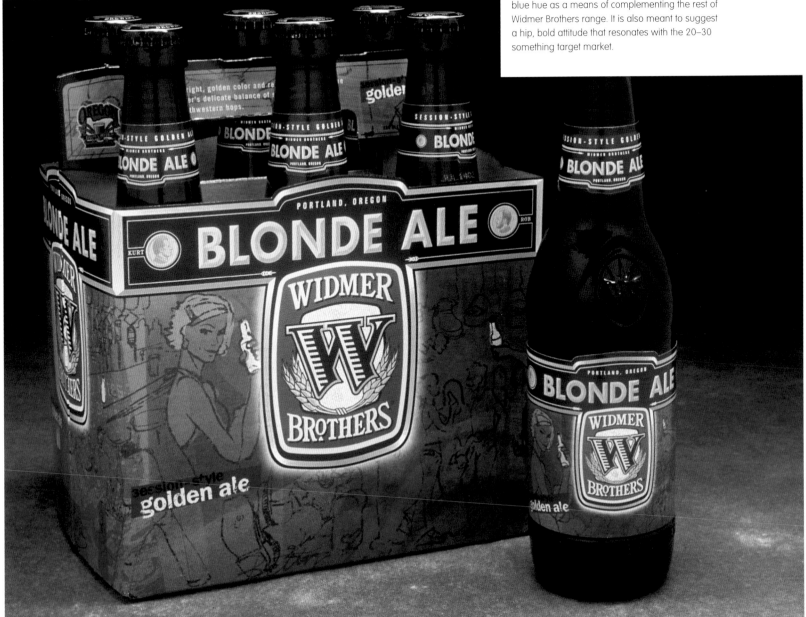

client: Widmer Brothers
project: Widmer Brothers Drop Top
date: 2003
agency: Hornall Anderson Design Works
designers: Jack Anderson, Larry Anderson, Jay Hilburn,
Bruce Stigler, Elmer de la Cruz, Dorothee Soechting

Carving out a new niche within the amber beer market for this product, the designers focused on the tradition of slow-paced, easy drinking in an effort to attract younger, independent-minded consumers. Christina Arbini of Hornall Anderson Design Works says: "The design reflects the simple, authentic personality of unintentionally stylish consumers. They are skeptics at heart, neither mainstream nor trendy. The result is a solid, confident personality that's honest and original, incorporating a feeling of freedom for uncomplicated moments."

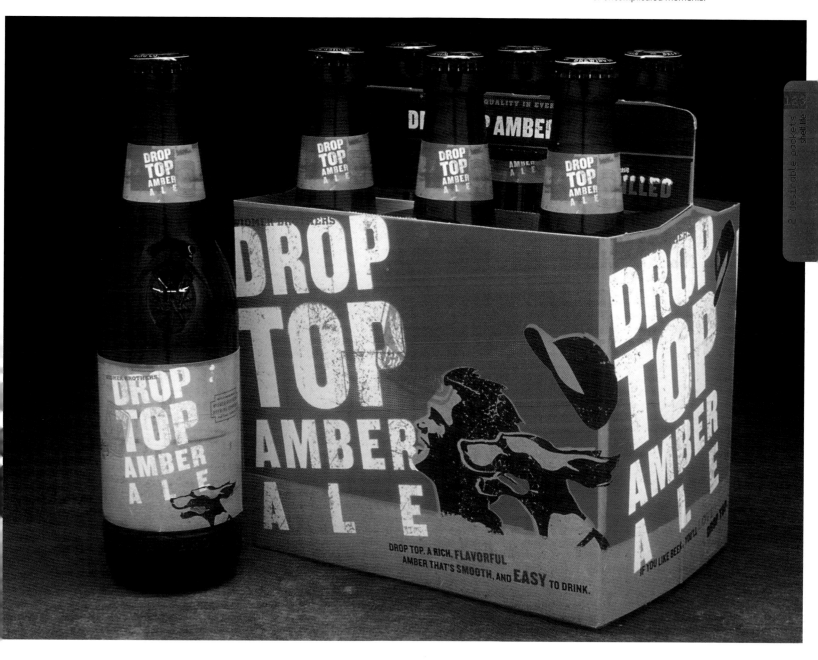

2 desirable pockets
shelf life

client: Paul Suzman
project: ZipSticks
date: 2002
agency: Hornall Anderson Design Works
designers: Mary Hermes, Andrew Smith, Sarah Kitchen, John Anderle

The objective was to create a brand name and packaging for a healthy, pure beef snack, cured in handcrafted small batches. As ZipSticks are natural, high-protein, low fat, and include no chemicals or artificial preservatives, the goal was to create a method of presentation that would distinguish the brand from oily, jerk products. Accordingly, the strapline became: "Your different breed of snack."

It was also important to get across how the product is made on the packaging, which is achieved through a message about its handcrafted quality. The price tag, flavor names, and the addition of real batch numbers are also key contributors to the brand's message.

Sokol Blosser, a strong regional brand in Oregon, wanted to create a white wine blend product that would serve as a distinct brand perfect for casual occasions. Says creative director Steve Sandstrom: "We named the product 'Evolution No 9', reflecting the fact that it contains nine varieties of grapes, harvested during the ninth month of the year. The result was a new wine product that had the guts to convey a unique yet confident personality."

Each bottle of Evolution No 9 includes a neck tag that helps to explain the name of the product. It lists some of the varieties of grapes that go into the wine, but also compares this "evolution" to the process, according to Sandstrom, that created "humans out of ooze, and bomber jackets out of leisure suits."

client: Sokol Blosser Winery
project: Evolution No 9
date: 1999
agency: Sandstrom Design
designers: Steve Sandstrom, Sally Morrow, David Brooks, Kathy Middleton

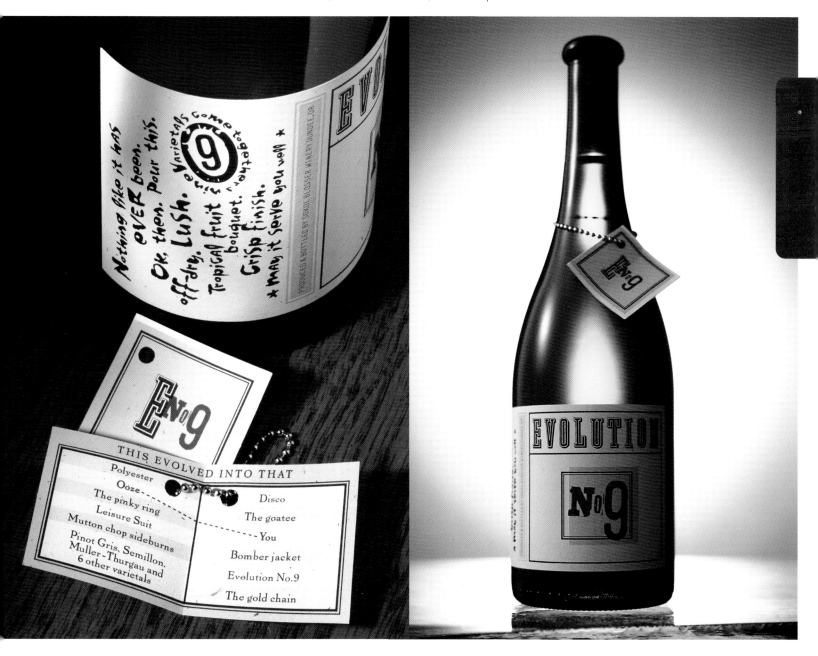

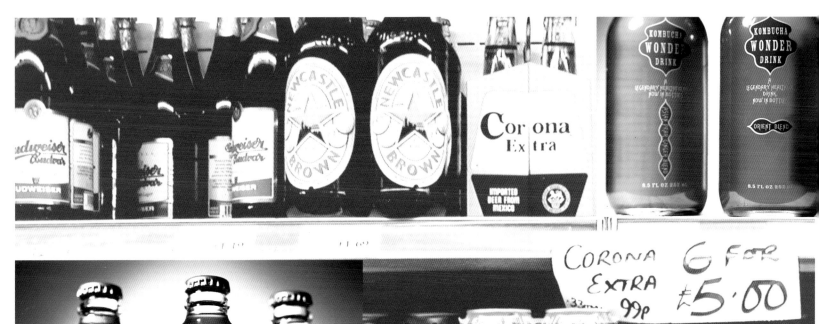

client: Kombucha
project: Kombucha Wonder Drink
date: 2001
agency: Sandstrom Design
designers: Steve Sandstrom, Michele Melandri, Craig Simpson, Ann Reidl

For more than 5,000 years, people have drunk fermented tea as a natural elixir. Still popular on several continents, it has been mostly a home-brewed drink in the US.

Brand and name development, packaging, and collateral for Kombuchas Wonder Drink were all created to reflect the drink's "mysterious and legendary properties." Based upon the design aesthetic for the drink, all marketing materials were created to appear old and new, modern and ancient.

Creative director Steve Sandstrom says: "Using elements and type that are both timeless and dated, they all combine to develop a look that is hard to nail down, freshly tasty, and distinct from any other beverage. The bottle is always depicted floating slightly above the ground, and on the website it hovers and sways slightly."

client: Dreher Breweries
project: Tuborg Beer
date: 2003
agency: Rexam Glass

Rexam Glass, one of the largest packaging producers in Europe, won the commission to produce this new bottle for Hungarian brewer Dreher's Tuborg Gold brand beer. The 33cl glass beer bottle—produced in olive green, with a twist crown cork—appears normal, but actually incorporates a clever design innovation: a twist-off opener.

The base of the Tuborg Gold bottle is designed with a star-shaped recess that allows the consumer to open a bottle by inserting the twist crown cork of one bottle into the bottom recess of another—handy for those moments when everyone's forgotten their bottle opener and you don't fancy losing your teeth—also a good gimmick to encourage multiple purchases. A counter-clockwise turn opens the beer. Since introducing this bottle in January 2003, Dreher has reported a 50 percent growth in sales.

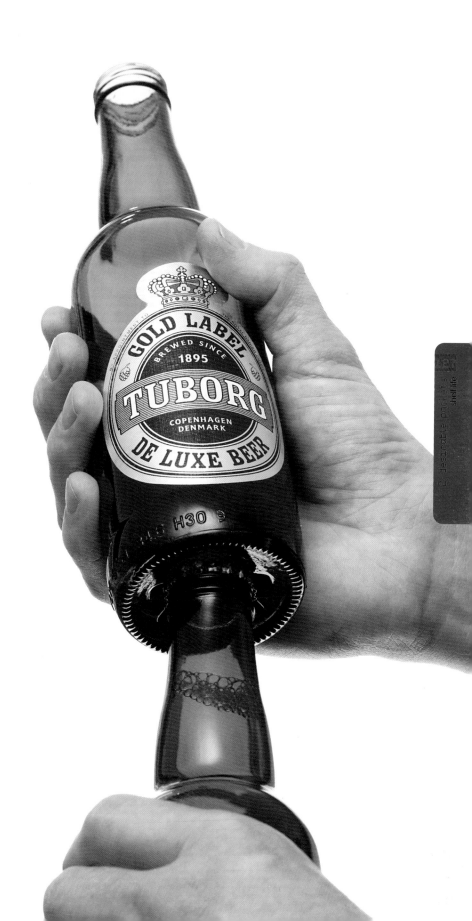

client: Honey Baked Ham Company
project: Dinner Good-To-Go structural packaging and identity
date: 2003
agency: Lipson Alport Glass & Associates
designers: Rob Swan, Anna Shteerman

The structural design acts as a stacking freezer box, and can be adapted to become a handy travel package. Other elements of the packaging included bags to house the food products. The name and graphic identity are meant to emphasize convenience while conveying a rich, warm, and inviting feel.

client: Valeo Inc.
project: Valeo Energy Bars
date: 2000
agency: Source Design
designers: Mike Nicholson, Bernie Dolph

Valeo manufactures and distributes a broad line of lifting gloves, belts, and supports for American fitness enthusiasts. The firm felt that its packaging needed revamping to provide a platform for launching this new line of nutrition bars.

Chicago's Source came up with a more contemporary, relevant personality, in keeping with competitive fitness brands, through the use of a bold new brand identity, clean graphics that stand out amid the clutter of the nutrition bars segment, and illustrations that position the product benefits (energy and balanced nutrition) relative to the plethora of competitive options. The biggest design challenge was convincing client management that its old logo—a long-used, but little recognized, lizard character—could and should be replaced with a more contemporary, culturally relevant brand symbol.

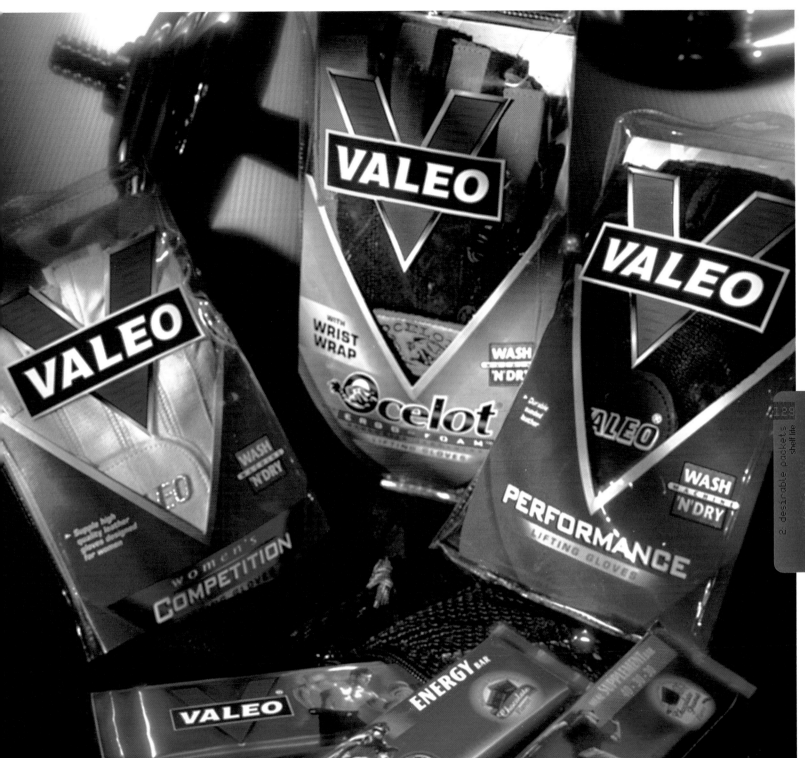

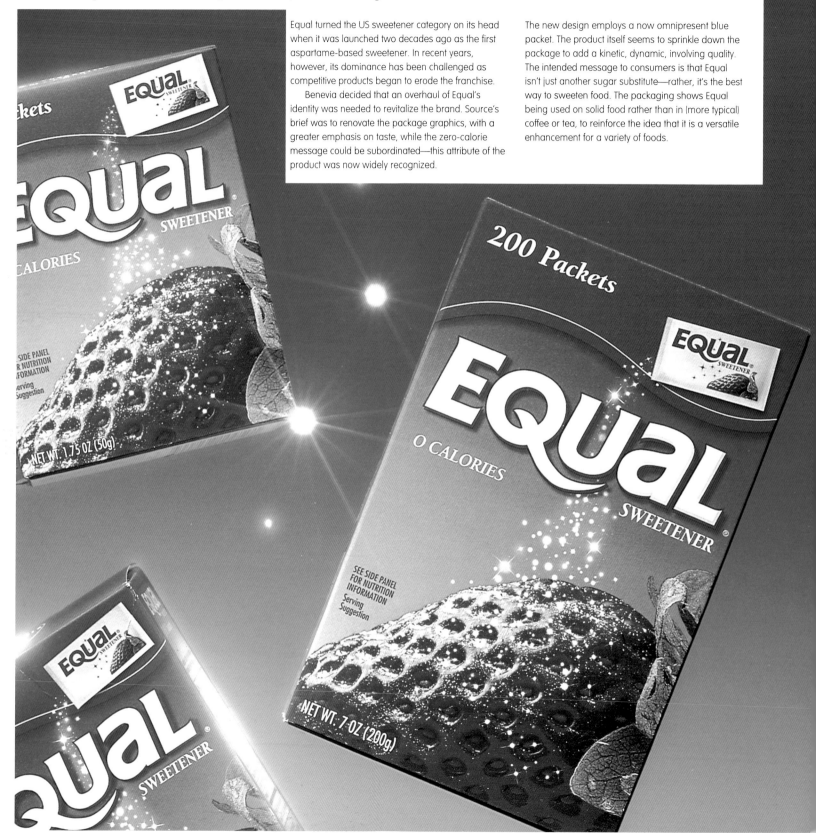

client: Benevia Inc. (now Merisant)
project: Equal Sweetener
date: 1998
agency: Source Design
designers: Mike Nicholson, David Lind, Jim Pietruszynski

Equal turned the US sweetener category on its head when it was launched two decades ago as the first aspartame-based sweetener. In recent years, however, its dominance has been challenged as competitive products began to erode the franchise.

Benevia decided that an overhaul of Equal's identity was needed to revitalize the brand. Source's brief was to renovate the package graphics, with a greater emphasis on taste, while the zero-calorie message could be subordinated—this attribute of the product was now widely recognized.

The new design employs a now omnipresent blue packet. The product itself seems to sprinkle down the package to add a kinetic, dynamic, involving quality. The intended message to consumers is that Equal isn't just another sugar substitute—rather, it's the best way to sweeten food. The packaging shows Equal being used on solid food rather than in (more typical) coffee or tea, to reinforce the idea that it is a versatile enhancement for a variety of foods.

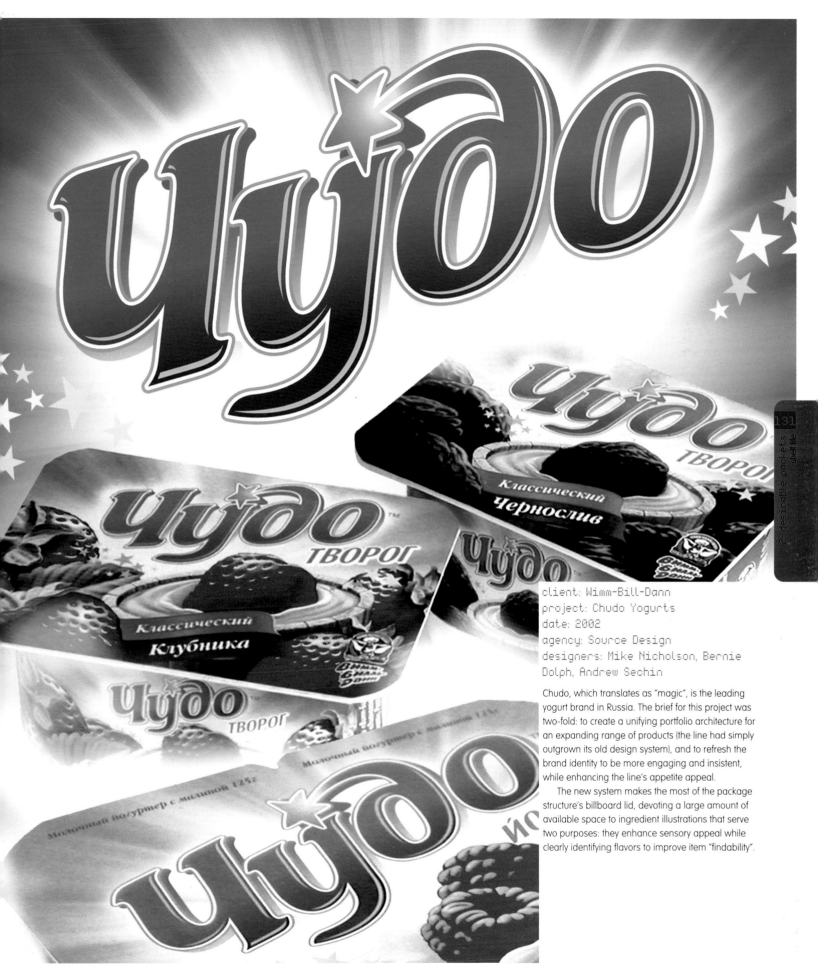

client: Wimm-Bill-Dann
project: Chudo Yogurts
date: 2002
agency: Source Design
designers: Mike Nicholson, Bernie Dolph, Andrew Sechin

Chudo, which translates as "magic", is the leading yogurt brand in Russia. The brief for this project was two-fold: to create a unifying portfolio architecture for an expanding range of products (the line had simply outgrown its old design system), and to refresh the brand identity to be more engaging and insistent, while enhancing the line's appetite appeal.

The new system makes the most of the package structure's billboard lid, devoting a large amount of available space to ingredient illustrations that serve two purposes: they enhance sensory appeal while clearly identifying flavors to improve item "findability".

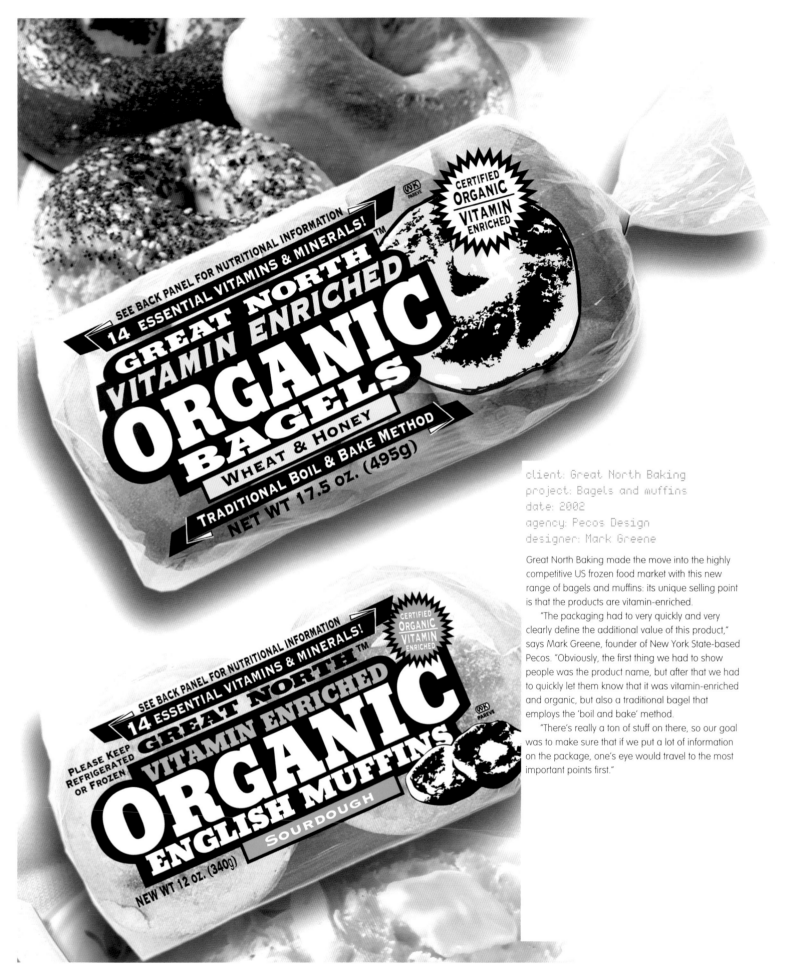

client: Great North Baking
project: Bagels and muffins
date: 2002
agency: Pecos Design
designer: Mark Greene

Great North Baking made the move into the highly competitive US frozen food market with this new range of bagels and muffins: its unique selling point is that the products are vitamin-enriched.

"The packaging had to very quickly and very clearly define the additional value of this product," says Mark Greene, founder of New York State-based Pecos. "Obviously, the first thing we had to show people was the product name, but after that we had to quickly let them know that it was vitamin-enriched and organic, but also a traditional bagel that employs the 'boil and bake' method.

"There's really a ton of stuff on there, so our goal was to make sure that if we put a lot of information on the package, one's eye would travel to the most important points first."

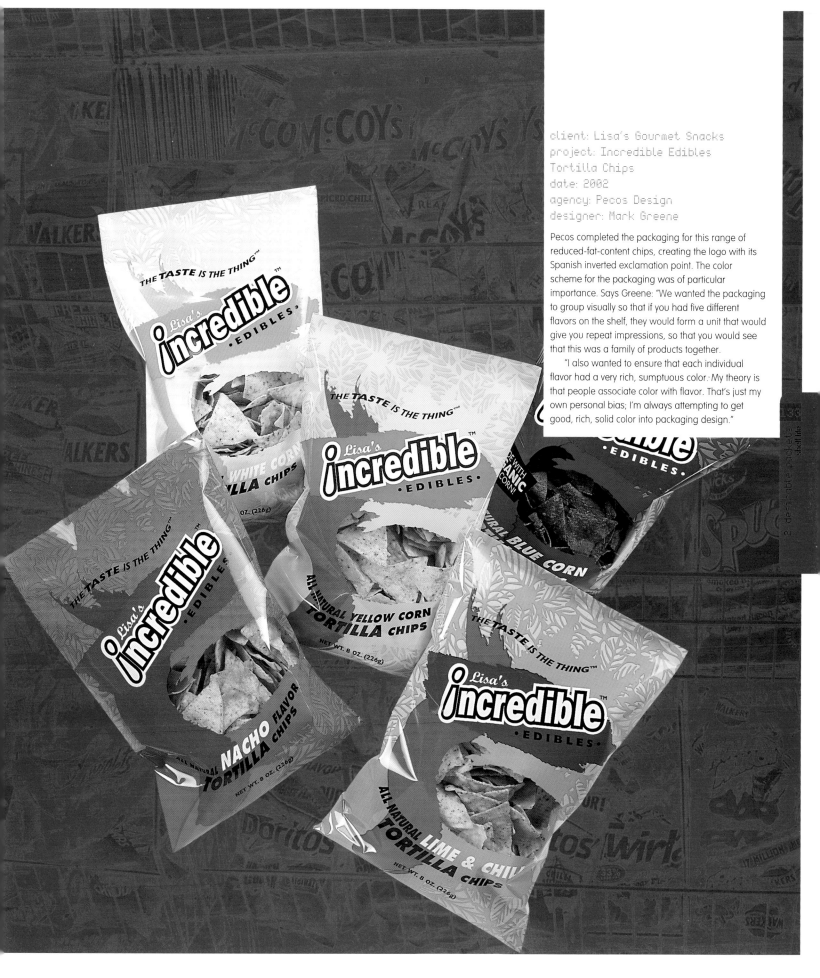

client: Lisa's Gourmet Snacks
project: Incredible Edibles
Tortilla Chips
date: 2002
agency: Pecos Design
designer: Mark Greene

Pecos completed the packaging for this range of reduced-fat-content chips, creating the logo with its Spanish inverted exclamation point. The color scheme for the packaging was of particular importance. Says Greene: "We wanted the packaging to group visually so that if you had five different flavors on the shelf, they would form a unit that would give you repeat impressions, so that you would see that this was a family of products together.

"I also wanted to ensure that each individual flavor had a very rich, sumptuous color. My theory is that people associate color with flavor. That's just my own personal bias; I'm always attempting to get good, rich, solid color into packaging design."

2 desirable packets shelf life

And so to (case) study. These design histories explore, in detail, the art of designing great food packaging, from some leading US and UK agencies. Lewis Moberly's work on Tamarind (page 136) is a fantastic example of the trend in which leading restaurants bring their own lines of products into the home, while Smart Design's novel packaging for Oxo Grind It (page 142) demonstrates that coming at food packaging as relative beginners is no barrier to creating award-winning design. Finally, we look at Sandstrom's work for giant US beer brand Miller (page 148), a comprehensive revamp that's effectively repositioned the brand in a highly competitive market.

design history: tamarind

brand: Tamarind
product: Chutneys and sauces
market: UK ·
agency: Lewis Moberly
designer: Mary Lewis

background

The Tamarind Indian restaurant in Mayfair, London, is one of the most prestigious in the world, being the first Indian to attain a Michelin star. Its range of spin-off products, however, has failed in the marketplace, and been delisted from major UK supermarkets. Tamarind calls in design agency Lewis Moberly to redesign the packaging for its chutney and cooking sauce products to radically address this problem.

stage 1
preliminary analysis

☀ Lewis Moberly creative director Mary Lewis analyzes the brand's previous packaging (above left). It is felt to be "too ordinary," lacking in shelf stand-out, branding, and generally "falling between two stools."

☀ Lewis looks at Tamarind's competitor products on the supermarket shelves (above right). There are brands such as Patak ("authentic and old fashioned") and Sharwood's ("institutionalized and Anglicized"), plus a host of own-label products, (notable for "tall, lumpy jars", bright colors, "noise," and a lack of subtlety). There are also more specialist offerings, such as Shere Khan (like Tamarind, proffering restaurant expertize), and Loyd Grossman (sauces endorsed by celebrity chef). Even here, though there is not satisfactory differentiation between these more premium lines.

☀ Conclusion: the market is "clichéd, tired, and overcrowded."

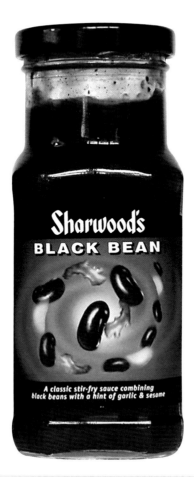
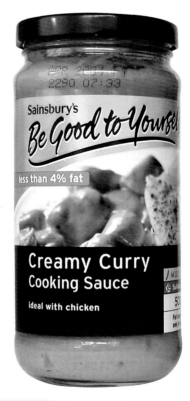

stage 2
exploring Tamarind as a brand

✳ Lewis Moberly looks at the ways in which Tamarind can find its own place in the market. Mary Lewis explains: "Our feeling on Tamarind was that there are more curries sold in the UK nowadays than fish and chips. So you don't need to be screaming, 'This is Indian': people know about that now. We didn't need to go down the route of cliché."

✳ What makes Tamarind stand out? The high-quality restaurant background lends the brand "excellent start-up credentials", leading to a possible positioning as a "modern day spice trader". The relatively unknown nature of the brand is plus: there is no need to be overprotective when carrying out the redesign.

✳ Tamarind's tonalities are decided: special, creating a sense of anticipation; surprising, eye-catching, and different; convenient—packaging and product delivery; contemporary, relaxed, stylish, and simple.

stage 3
Tamarind's opportunity

✳ To differentiate through an idea of "New India"—modern and stylish.

✳ The bottom line for the redesign: "No room for more of the same." A small brand must earn its space.

TAMARIND

TAMARIND

T A M A R I N D

Tamarind

tamarind

tamarind

tamarind

* Various typefaces are explored for Tamarind, both
 serif and sans serif. The sans serif versions are
 tweaked slightly to make them more distinctive. The
 decision is made to adopt lowercase lettering. Lewis
 says: "We thought that the Indian category is
 characterized by over-excited typography. There was
 a real opportunity here to do something a bit simpler.
 Lowercase was chosen because it's perceived as
 being younger and more stylish."

* In search of a graphical device to adorn the logo,
 Lewis explores the concept of using the "bindi", an
 auspicious make-up worn by young Hindu girls and
 women on their foreheads. The term is derived from
 "bindu", the Sanskrit word for a "dot" or "point".
 Usually a red dot made from vermilion, a bindi
 signifies female energy. Lewis adopts the red dot and
 places it over the "i" in the Tamarind typeface.

* Exploration of reversing the logo to white on black.

* Decision made to put the logo on the jar tops.
 Lewis:"Whichever way you turn the jar, the red dot
 remains central. We thought that was interesting, and
 it became the lid."

stage 6
jar development

✳ Given that competitor jars are tall, the Tamarind jars are designed to be short, squat, and rotund, as an extra point of differentiation.

✳ Lewis also feels that the jars would benefit from being tinted (as yet, Tamarind has not adopted this device, but it may feature on new products).

stage 7
label development

✳ The tamarind itself (a large tropical tree, originally native to eastern Africa, and now found in all tropical regions) is obviously considered as one possible route for the labeling, but it is rejected.

✳ Jali screens (ornate, carved sandstone screens) provide a source of inspiration. Lewis says: "These are used throughout India to shade windows and are built into lots of the architecture. They're just wonderful designs, very abstract, very rich. We felt they could be translated in a very contemporary way, so that became the starting point." Lewis picks out various abstract shapes from the screens and experiments by adding color. She develops two separate sets of graphics based on the screens—one for the sauces and one for the chutneys. "I decided that each group of products would have a series of individual shapes," she says. "There would be a certain tension between them, so each row would stand out on the shelf."

a fresh approach to indian cuisine
Prasad, our head chef at the
Tamarind Restaurant in Mayfair,
has added a dash of wine
vinegar and a hint of fresh
coriander to make this more
aromatic than traditional
Jalfrezi. We hope you enjoy
our fresh approach and would
welcome your comments.

● ● **classic jalfrezi sauce**
Cooking instructions: saute
chicken, diced lamb, prawns
or vegetables in a little oil or
butter until cooked through.
Stir in Classic Jalfrezi Sauce
and bring to a simmer for
2-3 minutes. Serve with
your favourite rice and
accompaniments.

● mild ● ● medium ● ● ● hot

classic jalfrezi sauce

tamarind

stage 8
back of pack development

＊ The red dot is used again—this time as a device to
 indicate the spiciness of the products. "Rather less
 naïve than using a chilli for this purpose, as is
 common," says Lewis.

＊ A story is incorporated to exploit the heritage of
 the restaurant.

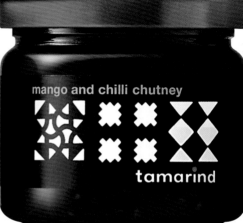

results

Tamarind has been relisted at Sainsbury's and other UK retailers and is so far proving a success. Other products may be introduced in the near future: if so, Lewis Moberly will design their packaging. There is plenty more mileage in the Jali screen-inspired graphics, according to Lewis—"they are a real lifeblood for the brand."

"We did a lot of strategic work on this project," she adds, "because we wanted to think about the Tamarind opportunity and what a small brand can do that a large brand can't. A small brand has got to be different—but that difference has to be the right difference, and not just for the sake of it. I think we've achieved something that is not Indian cliché—it is absolutely Indian."

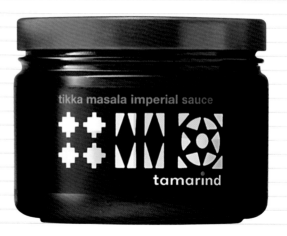

3: case studies
tamarind

design history: oxo grind it

brand: Oxo Grind It
product: New spice-grinding system
market: US
agency: Smart Design USA
designers: Nao Tamura, Paul Hamburger

background

Kitchen tool maker OXO International decides to diversify into food products with the launch of a spice-grinding system, a rarity in the US market at the time. Long-standing partner Smart Design is brought in to develop the packaging, grinding system, and graphics. This commission is a departure for Smart, too: most of its work involves product design for companies such as Hewlett-Packard, for which the agency has designed scanners and printers. This was its first food packaging project.

stage 1
grinder development

✳ The industrial design element of this project is of high importance. In other spice systems, there is a separate grinder for each spice. Smart Design wants to keep the cost of Oxo's product down by developing one grinder head that can be used for all the different spices in the range. Usually, there is a separate grinder for every herb and spice, or one grinder you must empty and then refill to change the herb. Purchasing separate grinders for each herb or spice is unnecessary, and costly. To refill just one grinder with different herbs or spices can be time consuming, messy, and impractical, as the various flavors and odors left in the grinder may clash.

✳ An iterative process of rapid prototyping and user observation is used over a variety of three-dimensional models to arrive at the best form, from an ergonomic and functional standpoint. The spice grinder head, which features a tough ceramic grinding surface, is designed for quick-release at the touch of a button. The final design has an ergonomic

"bullet" shape, so both the grinding mechanism and spice jar nestle comfortably in the hand.

Designer Paul Hamburger notes: "It's actually a very well-engineered product, and the overall shape is easy to hold and use. The way the grinder head snaps off and can be moved from one jar to the next is clever and nicely engineered. The engineers on the project had to work hard to pull that off."

OXO **Grind it**

1 Press the easy-release button & tip back the soft-grip grinder to remove the grinder from the spice jar.

2 Remove the tamper-evident freshness seal by pulling the plastic ring, & snap the grinder back on the jar.

3 To adjust the ceramic grinder, turn the gray wheel clockwise for fine and counter-clockwise for coarse.

4 To grind herbs & spices, hold the grinder in one hand & turn the jar back and forth with the other hand. Grind directly into your dish, or into the cap for measuring.

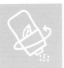

Herb and Spice Refills
Suggested retail $4.99

- ☐ Coarse Sea Salt
- ■ Black Peppercorns
- ■ Chili Pepper
- ■ Coriander
- ■ Cumin
- ■ Garlic
- ■ Onion
- ■ Rosemary
- ■ Lemongrass
- ■ Thyme
- ■ Basil
- ■ Oregano
- ■ Dill
- ■ Tarragon
- ■ White Peppercorns
- ■ Cinnamon
- ■ Clove
- ■ Ginger
- ■ Allspice
- ■ Citrus Blend
 (Lemon Peel & Orange Peel)
- ■ Peppercorn Blend
 (Black, White, Pink & Green Peppercorns)
- ■ European Blend
 (Rosemary, Tarragon & Thyme)
- ■ Asian Blend
 (Ginger, Lemongrass & Szechuan Peppercorns)
- ■ Latin Kick Blend
 (Cumin, Coriander & Crushed Red Pepper)

Herb and Spices Grinder
Suggested retail $19.99

- ☐ Coarse Sea Salt
- ☐ Empty Jar
- ■ Black Peppercorns
- ■ Chili Pepper
- ■ Garlic
- ■ Onion
- ■ Rosemary
- ■ Cinnamon

Herb and Spices Grinder Sets
Suggested retail $34.99

BASIC SET
- Coarse Sea Salt
- ■ Black Peppercorns

STINKY SET
- ■ Garlic
- ■ Onion

Herb and Spices Grinder Sets
Suggested retail $29.99

CLASSIC SET
- ■ Basil
- ■ Oregano
- ■ Thyme
- ■ Rosemary

BAKER SET
- ■ Clove
- ■ Ginger
- ■ Allspice
- ■ Cinnamon

LIGHT SET
- ■ Dill
- ■ Tarragon
- ■ White Peppercorns
- ■ Citrus Blend

BLENDS SET
- ■ Peppercorn Blend
- ■ European Blend
- ■ Asian Blend
- ■ Latin Blend

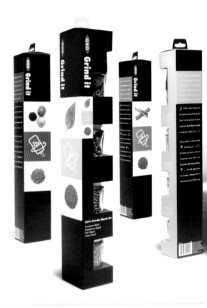

stage 2
spice "family" grouping

The desire to have just one grinding head for the spices causes some problems, and the design team realizes that using the same head on "incompatible" spices could lead to unpleasant mixtures of odors and flavors. The Oxo and Smart Design team decides to group all the spices in the range into distinct "families". The spices in each family will be complementary and so can share a grinding head. This categorization process requires the input of food specialists, who group appropriate herbs and spices. Based on their findings, Smart Design comes up with five or six separate categorizations for Oxo's product.

stage 3
color assignation and spice family naming

* Smart Design has to decide on an appropriate color scheme for each of the three spice families. The scheme needs to differentiate effectively between the families, but also suggest the cohesive nature of the complete range. Each family also needs a name.

* Each bottle in the "Classic" set—basil, oregano, thyme, and rosemary—uses a green cap. The "Baking" set—cloves, ginger, allspice, and cinnamon—uses a red cap. The final set, called (appropriately enough) "Stinky"—garlic and onion— uses a yellow cap. The simple and, in the case of "Stinky", somewhat irreverent choice of names is deliberate, and intended to make Grind It accessible to consumers, with a friendly, unpretentious feel. The use of bright colors adds to the notion of accessibility.

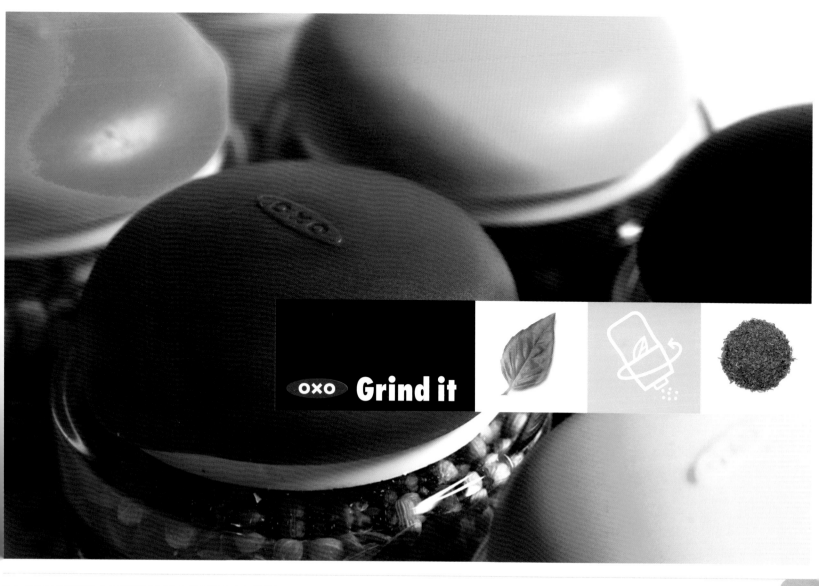

OXO Grind it

stage 4
logo and pictogram development

❋ The concept of fresh-grinding anything other than pepper or coffee is unfamiliar to the average US consumer, so Grind It's packaging has to quickly introduce, explain, and demystify the system of grinding herbs and spices. Hamburger says: "If you're in a retail environment, people are not going to consider things for very long—we needed to create something that would distinguish this product from a normal spice set, and get the concept across."

❋ Along with the logo, Smart Design creates a very simple pictogram featuring a picture of the whole spice, an icon of the grinder, and a pile of ground spice, to tell the story of fresh spice grinding in a quick and immediate way. Hamburger adds: "We needed to make a clean and simple statement that people would be able to assimilate in a crowded retail environment, and as a result, the design is quite minimalist. We were happy that it wasn't typical garish food packaging, but the important thing was to make sure it would be effective."

stage 5
collateral material development

"What's really cool about Oxo Grind It is the smell of the spices—the difference between freshly ground spice and pre-ground spice is in the aroma," Hamburger explains. "When people use the product and smell it, they get excited, and we wanted to give people that experience in the store."

Smart Design thus creates a point-of-purchase display inviting people to sample the product.

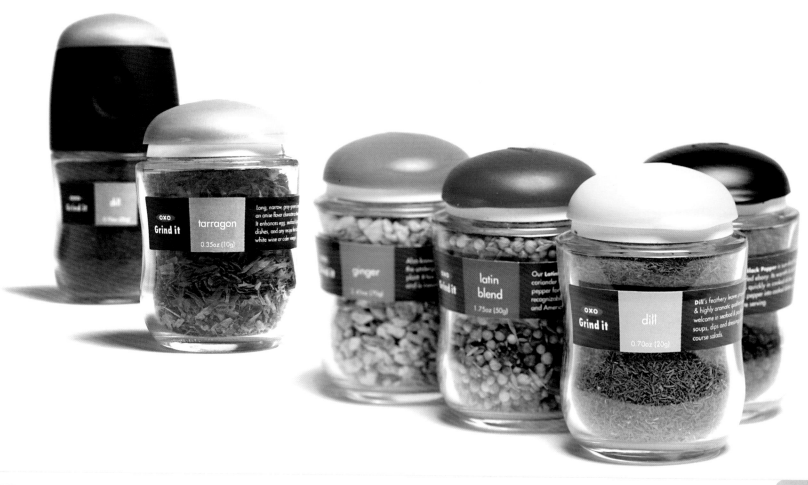

results

Although Grind It has had difficulty opening up new channels of distribution, the product is beginning to make significant inroads into the US market. Smart Design's work on the system, meanwhile, has won the approval of the agency's peers in the design industry, being recognized as one of the most outstanding examples of food packaging design in the US in recent years. The packaging won an Industrial Design Excellence Award (IDEA) gold in 2002, and a Good Design Award 2002 from the Chicago Athenaeum. It also won best of category in How magazine's Design Competition.

Ironically, Hamburger believes that the success of Smart's design was partly due to its lack of experience in the food packaging area: "This product was very new to us," he says, "and that's one of the reasons we did a good job—we were thinking outside the industry and looking for a solution that was fresher. Working from a more naïve standpoint allowed us to educate everybody else a little bit better about the product, because we ourselves needed educating. We didn't know anything about cooking or

spices and we were all fascinated. Learning about the whole thing was interesting for us, and we wanted to create the same experience for people using the product."

Designer Nao Tamura adds:"We had fun during the design exploration, and I think our energy and curiosity is reflected in the design."

design history: miller lite

brand: Miller Lite
product: Miller Lite beer
market: US
agency: Sandstrom Design
designers: Steve Sandstrom, Starlee Matz
copywriters: Jim Haven, Austin Howe
project manager: Kathy Middleton

background

Lite beer was introduced by Miller Brewing in 1974, and changed the whole industry. In the US, light beers dominate the market, but Miller had been losing ground to its major competitors because Lite was considered to be a generic beer. By renaming the product Miller Lite, the group felt it could solve this problem and compete more effectively.

Sandstrom Design had already been working on the redesign of Miller High Life for Miller Brewing, and was asked to participate in a preliminary design round on the development of a new Miller Lite logo. Miller had been working with the design department of its advertising agency and required some additional input from the outside. Sandstrom's concepts were successful, and the designers were taken on to work on the packaging for the product.

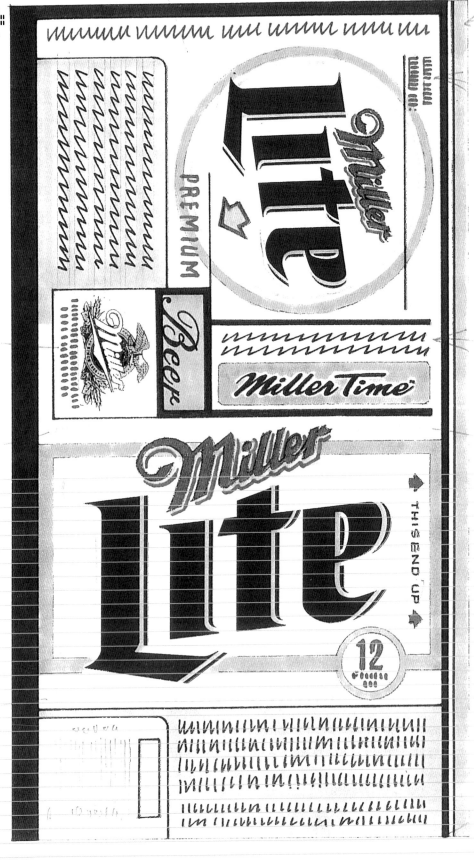

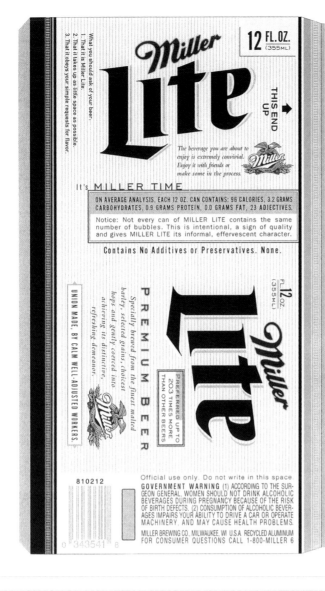
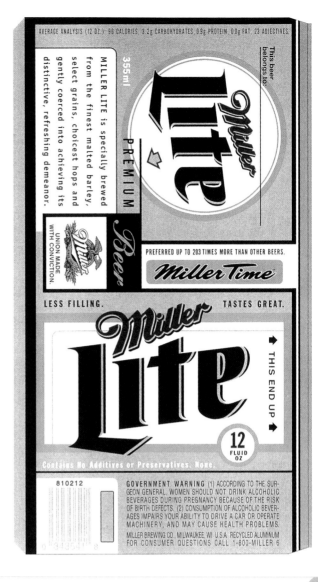

AVERAGE
ANALYSIS
COPY

THIS BEER
BELONGS TO:

PREFERRED
UP TO...

TASTES GREAT.

stage 1
brief and initial concepts

* Miller Lite, previously known as Lite from Miller or just "Lite", is suffering losses of market share to both Bud and Coors' versions of the beer. Miller is losing ground partially because it has never tied the product to the brewery name. This becomes the primary focus of Sandstrom's brief.

* The secondary element is to design packaging that appeals to a younger audience. The light beer market is growing in this younger segment. Miller needs to change its image to match the lifestyles and attitudes of younger people.

* Sandstrom produces two initial concept directions that feature slight variations on the same color palette, plus the revamped logo. Gold is added to both as a premium cue.

stage 2
phase two concepts

The first set of variations is chosen, and Sandstrom provides a range of further concepts for the packaging design, some of which are related to the current version, and other ideas that are far removed from the original packaging. There is some unity, however, as Rick Braithwaite explains: "The common thread to all of our designs was the new logo and a '360 degree' approach. We didn't want to have any dead zones on the can, where all the legal information is normally placed—and ignored."

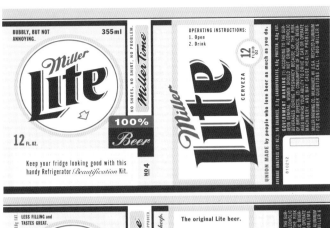

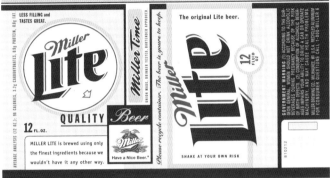

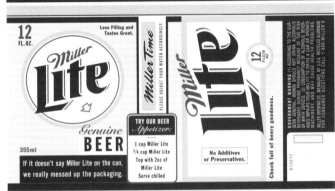

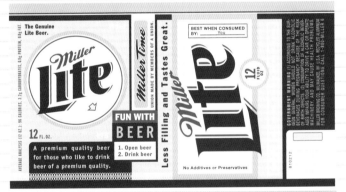

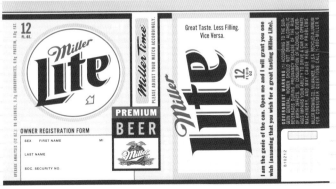

stage 3
collateral development

Sandstrom also produces a range of designs and
concepts for collateral materials, including
advertising, branding for Miller trucks, a
paint-by-numbers system, and wallet photos.

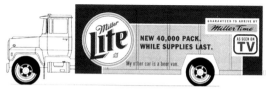

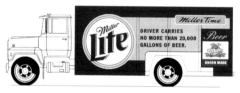

stage 4
final design development

A more contemporary, graphically interesting style is developed for the final concept, intended to appeal to a younger demographic and move away from traditional beer imagery—motorsport for example. Designing in 360 degrees means that the graphics are interlinked and overlap, rather than "a typical can with a front, a back, and some dead zones"—typical packaging has a graphic on front which is then repeated on the back.

stage 5
final design and market testing

✳ Braithwaite says: "Eventually, we reached a solution that was distant from Miller Lite's brand past—in fact where any beer packaging had been in the past." The can and bottle packaging is designed to be interactive through its use of copy and information, creating a "lighter, fresher, and more engaging" image for the product ("We wanted to create an experience for the consumer").

Filling up the space on the cans are brand icons, legal information, and a wide assortment of witty, sarcastic, and unexpected phrases. For example, "Miller Time is unaffected by daylight savings", "As seen on TV beer", and "Union made with cheerful enthusiasm".

✳ Blind market testing of the packaging designs meets with a positive response from consumers.

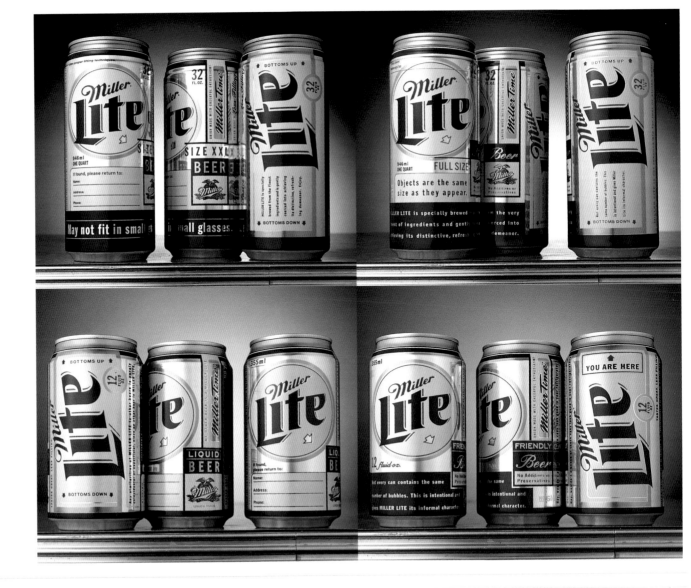

"We knew that the jokes would get old quickly. Our other big idea was to do multiple versions of each package every time it was released," says Braithwaite. Sandstrom recommends that Miller Lite's packaging is produced in several different versions, all to be rolled out at the same time, with new versions appearing every six months. Braithwaite adds: "It's a huge risk and change for a typical brewery, which doesn't normally want to change its packaging anyway, but we felt that this would give the brand more life and 'discoverability'."

Miller releases eight different 12-ounce cans for the launch. Each design features the new Miller Lite logo, as well as the same color combination and basic template. As a result, the beer packaging shares a look, but on closer inspection the differences between each design are revealed. Each design is numbered in anticipation of collection, since Sandstrom is also working on another release of eight new cans to follow up the initial launch. Braithwaite explains: "For the first time in beer

packaging, several different versions of artwork were released at the same time. They were sequentially numbered for those who like to collect beers, and the first run had eight cans and four bottles in circulation."

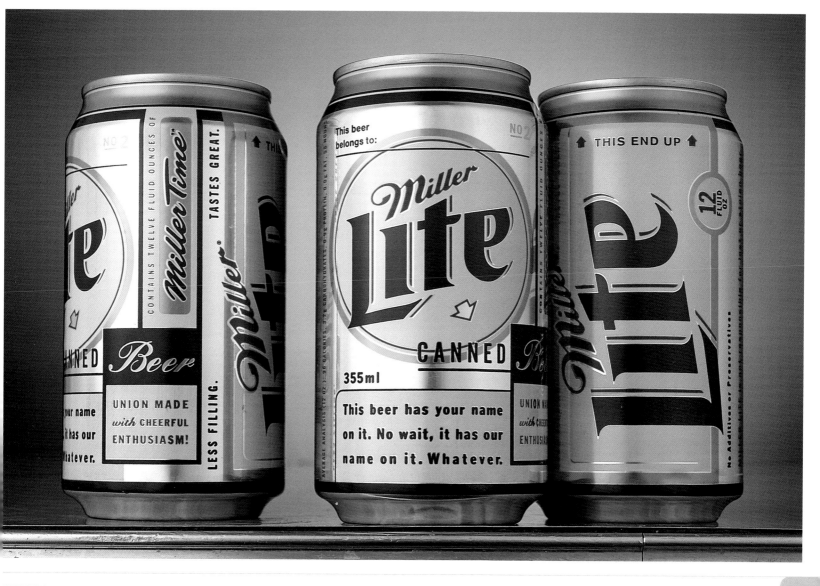

response

* Miller Lite's new look gets a good reception from consumers. "The response was very positive among the target audience," Braithwaite says. "They quickly adopted the brand energy we created, and sales were very positive. The advertising agency even began to create advertising that featured the packaging because of the response."

* Miller Brewing has a freefone number for consumers to call, which normally only receives a modest number of calls, 90 percent of these being complaints. Within one month of the packaging's launch, Miller receives 1,000 calls from Lite drinkers praising the new design.

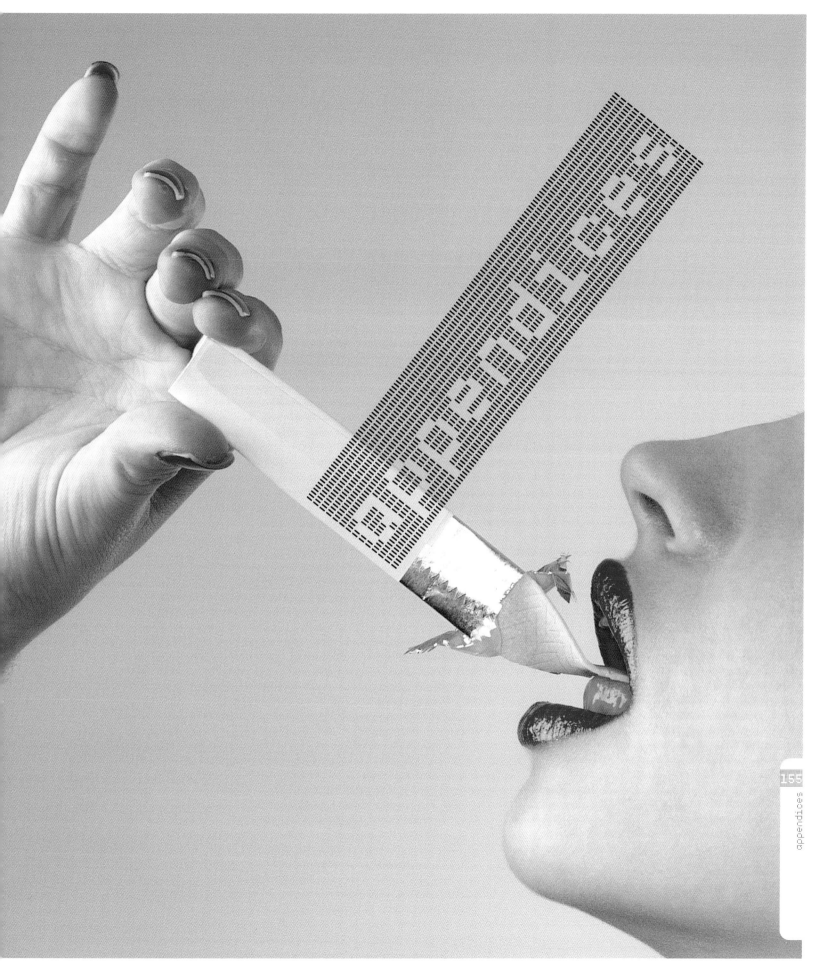

featured designers

index

acknowledgments

I owe a big debt of gratitude to all the designers and agencies who generously contributed their time, thoughts, words, and pictures to this project. Particular thanks, however, are due to Mary Lewis, Hilary Boys, and Sophie Stewart at Lewis Moberly in London, Daphne Nash and Paul Hamburger at Smart Design in New York, and Rick Braithwaite of Sandstrom Design in Oregon, for contributing to the design histories section. I am also extremely grateful to Domenic Lippa and Abigail Silvestre at Lippa Pearce in London, whose refreshing insights into this area of design really helped me get the ball rolling.

Much thanks are also due to Jane Roe at Rotovision for her excellent, thorough picture research, and Leonie Taylor, for her judicious editing of the text and patient toleration of numerous missed deadlines.

Finally, thanks and love to my partner Eve for all her support—and insightful comments on the drafts—during the writing of this book.

✳ Ben Hargreaves ✳